Book Design: Marcos Mateu-Mestre
Editor: Melissa Kent
Book Layout: Christopher J. De La Rosa

Published by
Design Studio Press
Website: www.designstudiopress.com
E-mail: info@designstudiopress.com

Printed in China

10 9 8 7 6 5 4 3 2 1

ISBN: 9781624650536

Library of Congress Control Number: 2020948700

FRAMED INK VOL. 2

FRAME FORMAT, ENERGY, AND COMPOSITION FOR VISUAL STORYTELLERS

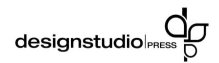

designstudio|PRESS

TABLE OF CONTENTS

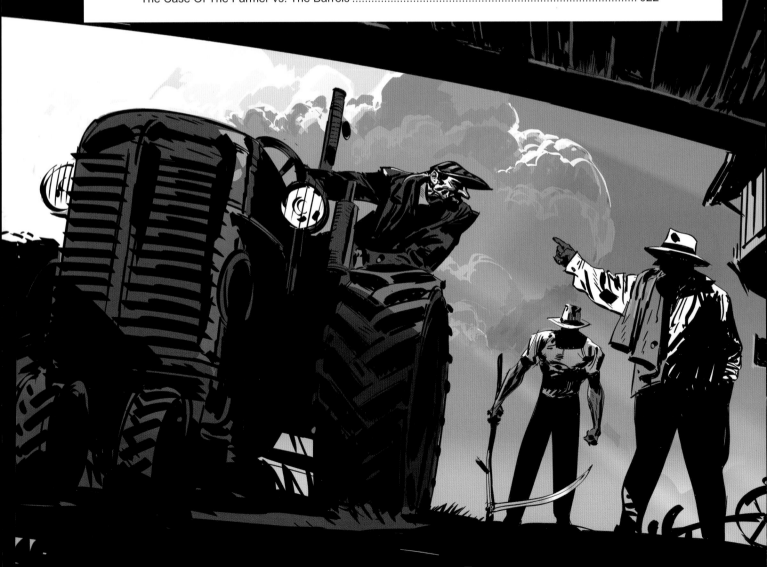

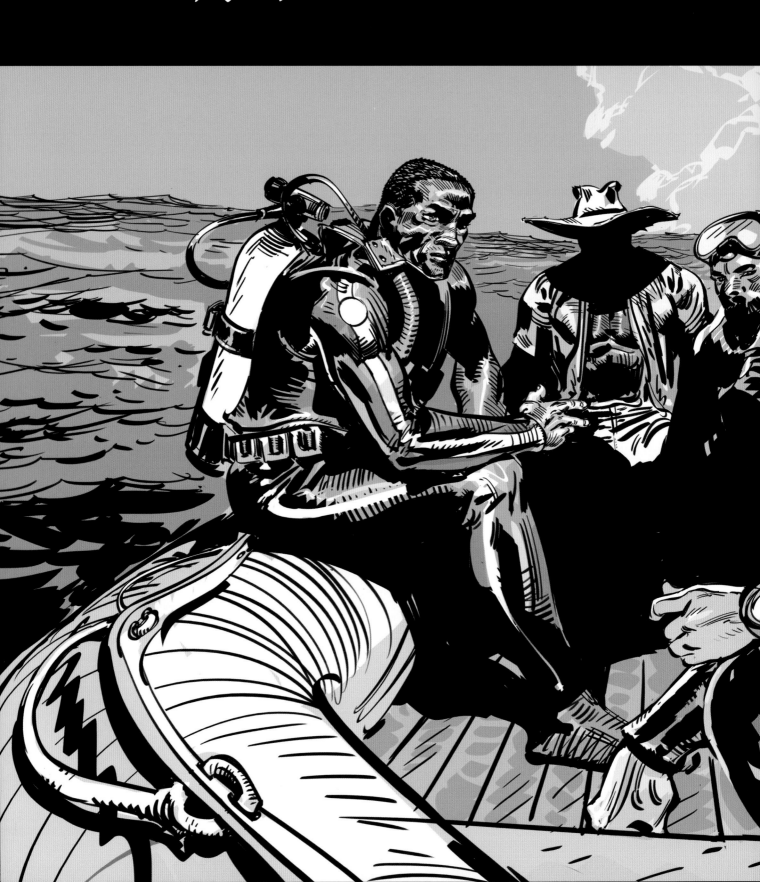

JOAN
MARGALIDA
CARME

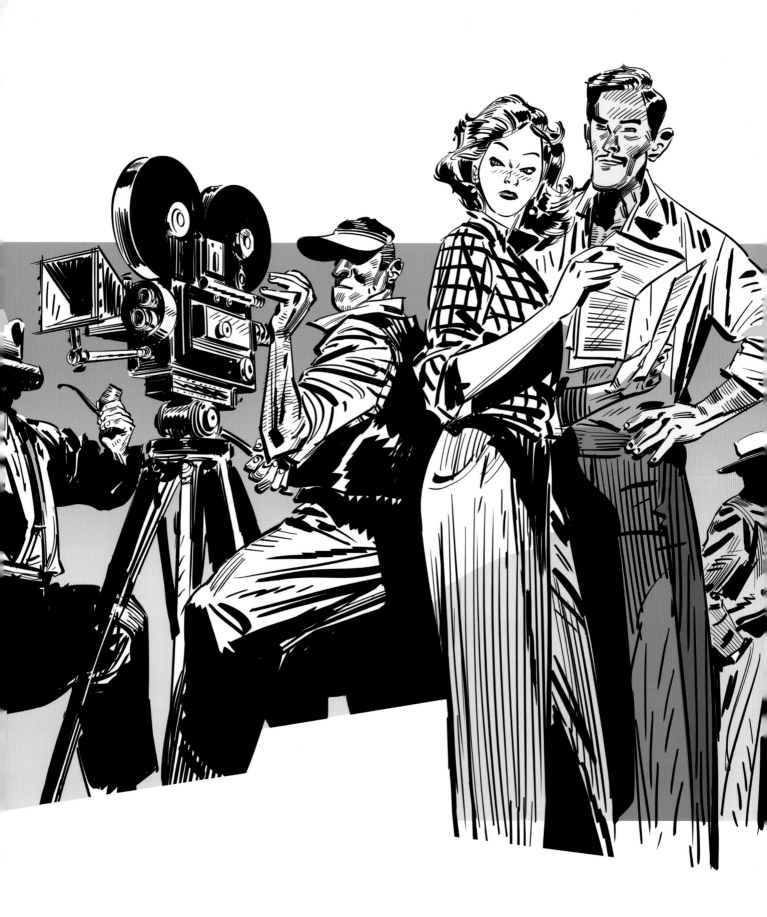

— INTRODUCTION

Welcome to the second volume of **Framed Ink**.

Writing a specific study on different screen and panel formats has been a long time coming for me, since **Framed Ink** focused mostly on the standard horizontal (landscape) ones. Since it was published in 2010, the proliferation of new electronic devices has radically changed and enhanced our possibilities in visual storytelling, taking advantage of every possible format: landscape, vertical, square, round, etc. This volume will explore how to harness the energy a shot must have in order to communicate meaningful emotions to the audience, and how the choice of frame format (aspect ratio) can enhance the storytelling even more. All of this will be shown through numerous practical composition examples.

Framed Ink 2 will provide you with the necessary tools to be confident in your use of visual language. As always, take all this information as part of a conversation in which you and the way you personally see and understand the world is the most essential part of the process.

So keep your excitement and motivation going, take all this in, and then have your own individual take on it. As they say, the sky's the limit.

MARCOS
MATEU
—Los Angeles
3. 20 20

My first book in this series, **Framed Ink: Drawing and Composition for Visual Storytellers,** analyzed how to compose an image by considering not only the physical elements or subjects that are part of a scene—be they characters, animals, dirt roads, mountains, clouds, bookshelves, or pillows...whatever might be the subject of our story moment—but also how different lighting situations can create very different visual realities.

Framed Ink also discussed how the thoughtful and purposeful interaction between the physical elements and the lighting creates an emotional impact on the audience, designed to serve the need of that particular moment in the story within the context of the full narrative.

In order to nail an emotional moment visually, it is important to be very clear about what tone such a moment requires. Is it about calm? Crazy action? Contradiction? Romance? Comedy and fun? Being clear about the function each bit of the story plays within the general context is essential. Creating the appropriate visual language or using the appropriate visual tools that moment requires is just like dressing for an occasion. And the question is, what is the occasion? Are we attending a New Year's Eve party? A funeral? A picnic by the beach? Or are we going to cross the Amazonian jungle in search of our favorite cousin who crash-landed his single-engine plane in the middle of nowhere? **What is the point of any particular scene or moment within the story** and how will we have to visually tackle it in order to deliver the right results?

A deep analysis of these and many other fundamentals is the main content of the previous book.

VARIETY OF SCREEN FORMATS

This new book, **Framed Ink 2,** focuses on a very special challenge: composing narrative elements for any screen or panel format, and all that implies. We will look at composing for not only movie theater or television screens but also for graphic novel panels, illustrations, and let's not forget the numerous opportunities on social media using computer or smartphone screens.

So basically, we play with two concepts here: **frame and format. Frame**—meaning the limited surface we play on, the area where we display the elements we count on to tell the story. And **format**—the specific height and width proportions of the frame, **its aspect ratio.**

The options are endless. Movie theater screens have been reshaped many times in their history for a variety of reasons. The 1920s saw ultra-widescreen statements like Abel Gance's *Napoleon* with its 4:1 aspect ratio (meaning the width of the screen was four times its height), although until the 1940s most movies' aspect ratio was an almost square 1.33:1 (a.k.a. 4:3). Once television became popular, also using the 4:3 format, and theater attendance dropped, movies differentiated themselves by embracing the widescreen experience, like Cinerama's spectacular 2.59:1 in the early 1950s.

Later on, standard formats for movie screens went to ratios like 1.85:1, or the wider 2.35:1, to be followed in the 1990s by widescreen 16:9 TVs.

Social media platforms have adopted new ways of displaying images, like Instagram's 1:1 square format, or smartphones that offer the possibility of composing images in either a vertical format (portrait) or horizontal format (landscape) with just a tilt of the camera.

Graphic novels have no pre-established formats so anything goes.

The main difference between a movie screen and a comic book panel is that the former maintains a fixed aspect ratio throughout the entire film, while the latter has pretty much all the flexibility in the world. Then again, a camera with its fixed format still has the ability to pan, tilt, zoom, dolly, truck, etc. The printed panel remains static, yet it has the ability either to stand alone or combine with other panels on the same page or double-page spread to achieve the desired dramatic affect.

SOMETHING THAT APPLIES TO ALL FORMATS

So, we have a point of view. It could be through a camera, our eyes, or maybe only in our imagination. And there is a subject, or number of subjects, in our sights, normally placed within a specific reality—let's call it the background or environment. And all of these elements are like oranges in our hands that we must juggle at the same time.

Normally, adjusting from one aspect ratio to another while trying to tell the same story through the same actors, subjects or objects, will imply, for the most part, a degree of rethinking the overall point of view and composition. It might be necessary to change the camera position a bit, or a lot, or tilt or pan.

For example, to show a line of people, we can do it from the side and show all the characters one next to the other, that is, if we are using a landscape format. But if we are shooting with a vertical screen lens, chances are we will need to go to the head of the line and see the characters overlapping one in front of the other, in order to fit the line into the vertical frame.

Other challenges that can arise due to screen format might be how to create a sense of extreme height while shooting a panoramic 2.35:1, or how to represent a strong sense of horizontality while shooting with the vertical lens of a smartphone. Again, **one must understand the intent of the shot, story point or story moment,** and then work out how to put the scene together to achieve its purpose.

Framed Ink 2 gives many practical examples of what I'm proposing here: not to just grab the same exact drawing or composition and crop it into one format or another, but to try to *get the most out of the possibilities* that different panel formats can offer any given moment, without breaking the integrity of the visual message that informs that part of the overall story.

To be fair, the example that most clearly represents a *potential* exception to this rule of "rethinking the whole shot" is the subtle step between framing something in two very similar, very common aspect ratios: 1.85:1 and 2.35:1. This, by the way, is the subject of special study in chapter 5.

THE FLOW AND TENSIONS WITHIN A FRAME

This book also provides many examples using concepts like **action vs. reaction, points of pressure vs. areas of release, lines of tension vs. easy flow, and turning points within the frame** or—as I call it, the game field—in ways that connect, relate and give dramatic meaning to all areas of the frame simultaneously, as a visual unit, regardless of its format or aspect ratio. Energy and flow, just like air and water, whether calm or stormy, will always adapt to the space (format) available to them. This book aims to offer plenty of visual and practical examples of what this all means and how to make it work to your advantage from the moment you begin.

ONE FINAL RECOMMENDATION

I strongly recommend keeping it as simple and abstract as possible in the first steps of creating a narrative image or series of images. Draw thumbnails or basic sketches, using primary lines, volumes, and proportions, to establish the essential dynamics and energy of the shot.

The main goal is not to draw, say, a horse rider in the middle of a desert, but to draw his or her moment of joy or drama, quiet or tension, a sense of being lost or a sense of achievement, in the life of this character at this point in time. This will inform what paths open in the story ahead. Once we establish this sense of energy and the visual guidelines, the actual horse and rider become "just" the physical support and expression of the emotional moment.

USING THE FRAME'S SPACE

(AND THE ENERGY WITHIN)

Let's dive into the realm of the abstract for a moment. In *Framed Ink* many panels were accompanied by **two thumbnails:**

a total abstraction of how the **lights and darks** worked within the composition, and...

the most simplified expression of the **lines of tension** within the drawing. These can be straight or curved. They express the main physical lines within the drawing—they can be the top of a mountain range, a strong tonal border between light and shadow, or a tall building's vertical line. Or they can be imaginary lines connecting the main focal points within the shot, like a line of cars, or a line connecting the heads of the main characters.

Figs. 1.1 and 1.2: Let's imagine a surface within which to compose a scene, and let's say this area is **36 square inches.** But remember we can vary its length and width to obtain different aspect ratios.

12 x 3 and 3 x 12 . (a 4:1 ratio)

8.50 x 4.25 and 4.25 x 8.50 (a 2:1 ratio)

6 x 6 . (a 1:1 ratio)

Fig. 1.3: For this exercise, a single black square represents a subject within the shot, which we will move around within the different aspect ratios to analyze the visual consequences of each position.

Later we will explore more complex situations, but for now let's keep it really simple.

The frames:

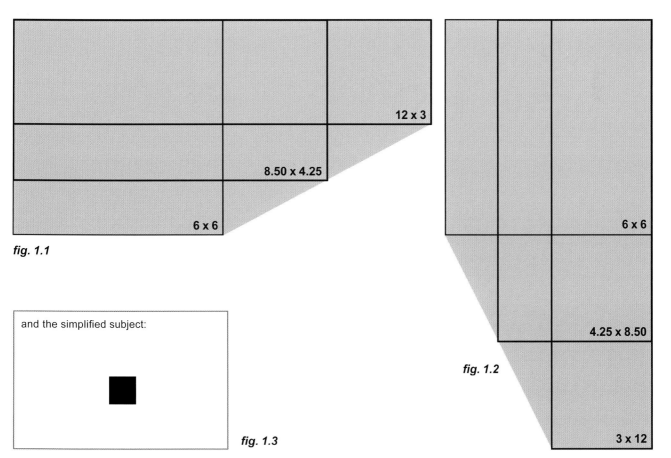

12 x 3

8.50 x 4.25

6 x 6

fig. 1.1

6 x 6

4.25 x 8.50

fig. 1.2

3 x 12

and the simplified subject:

fig. 1.3

So, we start with a panel, our **game field,** and we have our main **subjects** (characters, objects, environments) positioned within it. **The interaction between the frame and the elements within it** helps to tell the story. The subjects may be few or many, big or small, and no matter the frame's proportion or aspect ratio, what is most important is how we combine all of the above in order to service our narrative goals.

Let's begin by exploring how **the energy of the shot shifts around the moment we start moving the subject within the frame.** Starting simply gives us an overview and allows us to think purely in terms of **how a subject relates to the space around it.** So, actions and reactions interact with the frame in a way that gas or a fluid adapts to different containers.

Figs. 1.4–1.7: Our first example shows one of the frames from fig. 1.1, measuring 8.5 x 4.25, which is in fact a 2:1 ratio, meaning its length (8.5) is twice its height (4.25). As the subject moves within it, observe the results.

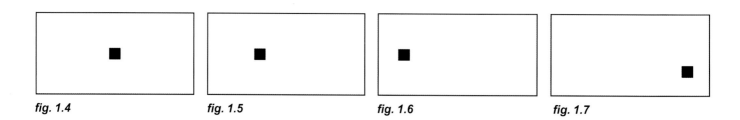

fig. 1.4　　　　　*fig. 1.5*　　　　　*fig. 1.6*　　　　　*fig. 1.7*

This exercise is not just about moving a little square around, but about a square, the space around it, and the relationship between the two that changes the focal point and perception of the whole situation or composition with every move of the subject.

Fig. 1.8: The main subject (the square) is placed within "air" (the white dot), surrounded by spaces represented in grey while the white areas represent the areas of balance and counterbalance created by the relative position and movements of the square within the frame. By centering the square or subject within the frame everything around it is equally spaced, which gives us a sense of things being balanced and resolved.

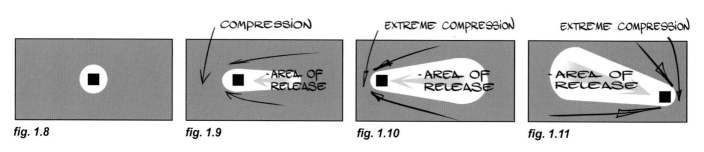

fig. 1.8　　　　　*fig. 1.9*　　　　　*fig. 1.10*　　　　　*fig. 1.11*

Figs. 1.9, 1.10, and 1.11: By **pushing** the square around in the frame, the space or "air" around it gets "compressed" against the side the frame it is closest to, while decompressing or liberating the space on the opposite side, therefore creating a disproportion and an instinctive need for resolution within the field. That is, drama.

It is like having an elastic band in my hands that I move, stretch, squash, deform, push and pull in different directions while simultaneously using my fingers to create all sorts of shapes, balances or imbalances between the various stretching points, **but always understanding that all points are connected, and that repositioning one affects the others as part of a bigger shape. Always.**

Tension and energy are created by pushing elements around the frame so that they generate fill-ins, voids, proportions, disproportions, balances, imbalances—in a nutshell, actions and reactions. Subjects are orchestrated in a way to deliver the punch (or lack of) needed for the shot's message to be understood. **This principle applies for any panel's aspect ratio.**

And regarding these areas of release or voids left by the moving object, it doesn't necessarily mean that you need to place another physical subject in the void in order to counterbalance the image. The void, or negative space, can sometimes become a subject in and of itself.

Imagine, for example, a shot where a small (relative to the frame) skydiver in the distance is falling fast from a plane that's not even in the shot and there is nothing else around her, not a cloud, not a bird, nothing but a flat, blue sky. That immensity around our character will become a very active narrative element in the shot. It is the very thing that tells us how precarious and dangerous her situation is, and it is the very thing that shows us how small she is up against an overwhelming space that controls her fate.

So, we are always creating connections and relationships between the different elements in the shot. **When we establish an action** (by moving or positioning elements around) **we also create a reaction.** Even when centering a subject in the middle of a frame with perfect balance all around, that apparent lack of action is a type of action in itself.

The way our mind normally works is by instinctively trying to balance things out, so if we stare at a red surface and then suddenly turn to look at a white surface, we will "see" green, as it is the complementary or opposite of red. Our brain is trying to balance things out. The reason why it feels like an "extreme" situation when a subject is positioned up against a side or corner of the panel is always because of its relationship to its game field (the frame), **without which such subject's position would be absolutely meaningless.**

Figs. 1.12–1.15: Here these concepts of balance, compression and release are applied to a square aspect ratio.

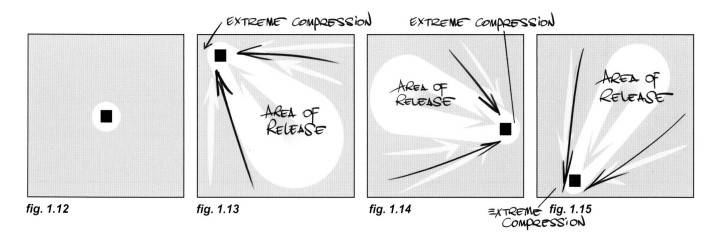

fig. 1.12 fig. 1.13 fig. 1.14 fig. 1.15

Figs. 1.16 and 1.17: In these shots of a horseman in the desert, both the sky and desert are simplified. The desert is really overexposed and bleached out, which helps establish it as a bulky mass. This mass can either support the horseman (fig. 1.16) while relaxing the scene, or push him (fig. 1.17) while adding tension.

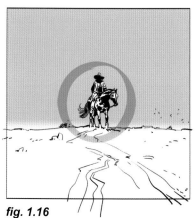

fig. 1.16

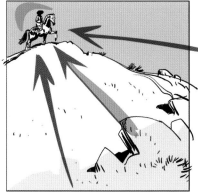

fig. 1.17

Extreme (sometimes odd and/or unusual) placements within a frame can work out as long as we know how to play the tensions, or lack of them. And the story moment needs to call for it. As long as you understand the relationship between the subject's placement in the frame and the space around it, you'll be fine.

The surface area you play within is there for you, **it works with you, not against you,** so that you can tell the story. Work with the **actions and reactions** between the different elements in the panel, no matter what the aspect ratio is.

Let's continue to develop these energy schematics.

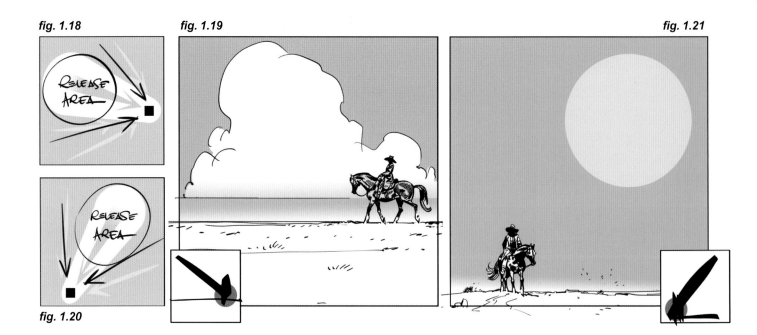

fig. 1.18 fig. 1.19 fig. 1.21

fig. 1.20

Figs. 1.18 and 1.19: In this dramatic composition the expanding cloud shapes in the void (or release area) balance out the horseman being pushed far down toward the right. These clouds do not take away from the rider's visual prominence. Rather than competing with him, they take him in, serving as his background, making him stand out by contrast.

Figs. 1.20 and 1.21: A visual dialogue is established by the action–reaction between horseman and sun. The contrast in the cowboy is accentuated compared to the more faded sun, stating that he is the main feature in the shot.

These two examples get away with unusual positionings of the main subject by properly playing the balances between tensions and openings within the frame. When doing so, the panel format does not matter that much. Speaking of which, how would a story moment like this look in a variety of aspect ratios?

SAME STORY MOMENT, DIFFERENT ASPECT RATIOS

In general, no matter the format, the moment we know the **elements** we have available to play with—whether they are three cars at a gas station, a grandma up against a complicated set of shelves in her old store, etc.—and the **emotional tone of the story moment,** begin by laying down the paths of energy (action–reaction) within the frame **at a very abstract level (bottom of fig. 1.21), creating a proper dialogue of basic lines and shapes within the panel.**

Personally, when I sketch these ideas on paper, **I don't pay attention to any specifics or details. I don't even look at the tip of the brush or pencil or what it is drawing.** I'm not there to do that; I'm there to create the right energy and set of balances **on the screen as a whole.**

We need to pay attention to both the shape of the frame and the subjects in our shot at the same time. I have joked that I draw the way a chameleon looks at things, one eye on what I draw, the other hovering over the whole drawing surface. (That's just a figure of speech, so don't go trying weird stuff now). This way, at any time, I know where everything is within the frame and whether it creates the right energy for what the shot needs. It's like being a coach during a game or a general during a battle, **you will have an overview position making sure everything works.** Remember, **all elements should be connected and helping push the same idea!** So keep them all in mind, all the time, while building your story moment.

- setup the game of spaces and tension lines (to be explained very soon!) for the shot in an abstract fashion,

- establish dialogues and currents of energy in a meaningful way. Make sure it creates the rhythm you want for the story at that very beat

- **have your drawing follow their path and lead, while making sure you don't lose the original raw energy!**

Next are some examples of how to work the same lone rider character, but now in extremely vertically shaped frames.

Fig. 1.22: This is a very rough sketch of how to play our field game in an interesting way. Raw and instinctive, keep it energetic even at this very abstract stage. A slight diagonal sets the pressure on the bottom area (in grey), counterbalancing a much bigger, lighter area of release above the horseman (the dotted grey rectangular area).

Fig. 1.23: Here the idea for the big, empty, release space at the top is to draw a cloud formation. Remember, each element in the panel must have a **purpose** beyond just being a cool, decorative thing hanging there. For example, the clouds here play out like a spectacular element in the landscape that overwhelms the cowboy. Keeping this thought, meaning and purpose in mind will lead us more easily and effectively to create not something that will appear to be just "clouds and a cowboy," but an imposing force (clouds) that overwhelms a lonely element (cowboy) in the middle of nowhere. **And that is a different feeling altogether.** Now we are **establishing emotional actions and reactions** between the elements in the shot and therefore **these now have a narrative function.** Thinking this way will guide your hand toward better and more assertive and expressive results.

Remember always to have a clear idea of the **subtext of the shot**—the emotion and meaning behind it. How do you want your audience to react? What does this moment mean to the characters in the story? We can only give what we have; if we don't understand the shot, we will end up with a number of nicely drawn elements on paper without a special meaning...*not our goal.* But what happens if we get rid of the clouds? is this automatically a bad move?

Fig. 1.24: What if this guy's best friend just passed away and he is looking for an emotional connection with the night sky? Or what if he is expecting the return of his pet falcon? Then the big sky, the immense void, over our guy would have a **story purpose,** right? And being aware of this purpose makes it possible to create full sequences of panels that push or stage a common and solid emotional thread.

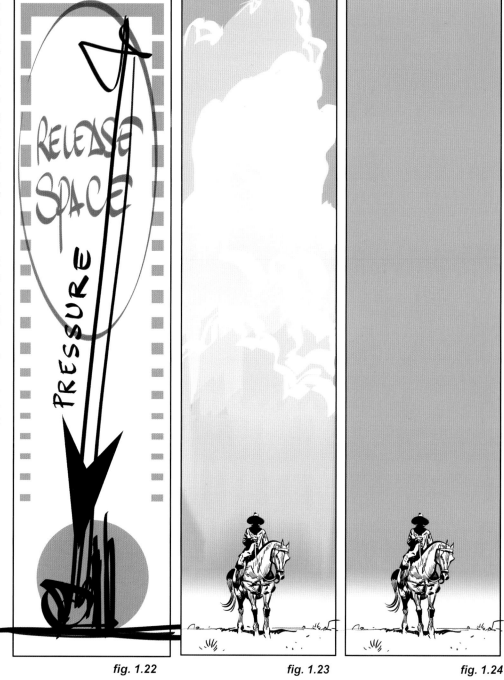

fig. 1.22 fig. 1.23 fig. 1.24

How can we apply this process to the same aspect ratio (4.30:1) but now rotated to create a panoramic view instead of vertical one?

For consistency, let's revisit the subject of the lone horse rider and try some options. Playing with the flow of energy and the use of tensions can help resolve situations that might appear pretty complicated at first glance.

Fig. 1.25: Again, the horseman is in a fairly extreme or unusual position within the frame, which creates tension and drama by action–reaction, pressure–release. In this sketch the situation is resolved by juxtaposing the concentrated energy of the rider up against the side of the frame with the expansive shape of the big mountain on the left. This makes for an epic feel of the character up against tall challenges. This is essentially the same flow of tensions played out in fig. 1.23, in which the rider is the focus of the visual dialogue, and the rest of the frame is filled in a balanced, purposeful way.

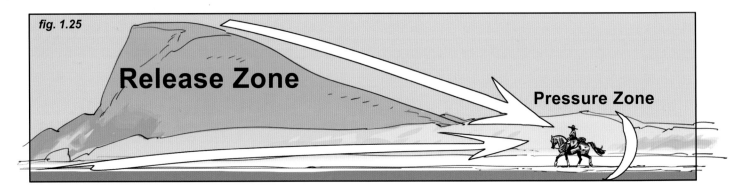

As long as all elements and areas have their own function and meaning, and we create a proper interaction between them, we are on the right path.

PLAYING IT DIFFERENTLY

Energy moves around, it flows, and it gives meaning and purpose to how the masses in our compositions work. Obviously, this flow does not always work the same way, otherwise we would be stuck with the same basic compositions over and over again.

Fig. 1.26: So here is the same cowboy again; he hasn't finished his long journey yet! To make it easier on him, let's change only his background, while keeping his position within the frame and the ground the same.

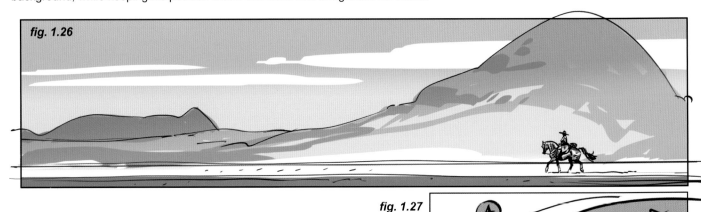

Fig. 1.27: The energy for this sketch is represented by two opposed or inverted funnel-shaped areas (**A** and **B**), such that they flow past each other while keeping their own territory within the scene.

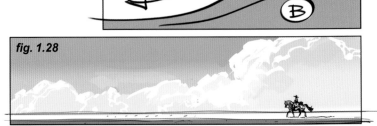

Fig. 1.28: Another option of how to play the same shapes and composition simply by changing the hill to clouds.

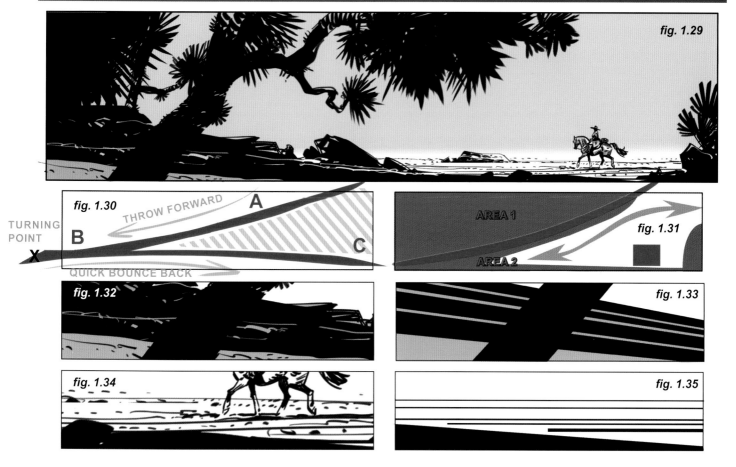

fig. 1.29

fig. 1.30 — THROW FORWARD — A

TURNING POINT — B — C

X

QUICK BOUNCE BACK

fig. 1.31 — AREA 1 — AREA 2

fig. 1.32

fig. 1.33

fig. 1.34

fig. 1.35

Figs. 1.29, 1.30, and 1.31: The horseman's journey continues in a shot that is roughly composed based on the natural, coherent motion of a ball being thrown from **A** to **B,** that then bounces all the way back to **C.** The strong slash of the black silhouette in the foreground pretty much rips the frame diagonally in two halves, while keeping some of the interflow between areas **1** and **2.**

With the camera this low, it can be difficult to discern which elements at the bottom of the frame are in the foreground, mid-ground or background, as they all look too close to each other. The foreground elements seem not necessarily close to the camera but simply gigantic. The solution is to **include as many depth clues as possible between the foreground, mid-ground and background.** (This is explained in full on page 071 of *Framed Ink*).

Figs. 1.32 and 1.33: There is a foreground trunk in solid black, more detailed mid-ground terrain, and the brightest area farthest from the camera. Overlapping these elements helps establish a sense of depth.

Figs. 1.34 and 1.35: Beyond the dark foreground, the terrain loses texture density as it extends into the distance.

Fig. 1.36: A simple empty space calls the rider toward his journey ahead.

Fig. 1.37: A minimalistic, raw energy sketch for this last shot. A line from left to right reaches almost all the way through the frame, then comes to a screeching halt (short, thick line) just shy of the frame's edge.

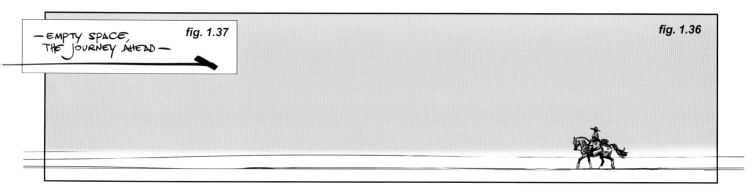

— EMPTY SPACE, THE JOURNEY AHEAD — fig. 1.37

fig. 1.36

In addition to plotting the energy of **full areas of the frame's surface** and how they react against each other, we must also consider the invisible or imaginary lines of tension that are part of the shot's narrative. These lines exist between the shot's key narrative points, emphasizing the various degrees of tension between them. That is, **the interaction between points within the frame determined by their relative placement to each other.**

On page 014 we imagined stretching an elastic band in various directions in order to establish one or more key points, which connect to create a simple straight line, a triangular shape, a square, a rectangle, etc. All of these key points would be physically connected by the rubber band itself, and each time we stretch it to a new place, we not only create a new point, but a completely new set of interactions on the panel. *The further we stretch it, the more we can feel the tension build, when we release it, we can feel the tension release;* all while simultaneously keeping a connection between the starting point and with all other key points on the panel, wherever they may land. Using this visual helps us experience the overall distribution of balance and tension in the panel as something vibrating and alive, and makes it **easier to adapt to any panel format.**

The **dynamics created by this relative positioning** between key points within a defined space, and the **level of tension between them** (how close or far apart they are), are very important. They create a language that contributes to the **very subtext of the scene:** the actions–reactions, balances–imbalances, compressions–expansions, laxity–tensions that can stretch all the way to a breaking point. This subtext is **the true story we are telling,** that is, how the characters feel about their moment or circumstances, which informs how *we* as the audience perceive it and feel about it. **The ink work of the drawing is the vehicle used to formally visualize all these abstract concepts.**

Fig. 1.38: An isolated key point (**A**) within a frame might represent the face of the main character, or the window of a room where an important action will soon take place.

Fig. 1.39: From starting point (**A**) we can create specific dynamics by "stretching the rubber band" toward a desired destination, key point (**B**).

This action establishes the tension and the connection between two key points, and gives the shot's dynamics the opportunity to adapt themselves and find their way around any format, aspect ratio or frame shape we want to use. This is a way to establish how the tension line(s) and the areas of pressure and release will react to and work with each other within the composition.

Figs. 1.40–1.43: These four scenes are practical examples of the relative positions of key points. Besides the facial and body expressions of the two characters, the tension and drama between them are also physically expressed by their relative position to each other within the frame: higher or lower, nearer or farther apart, bigger or smaller, as well as combinations of all these factors.

As a general rule, the further we stretch the distance between these characters and the closer they get to the sides of the frame, the more the tension will increase.

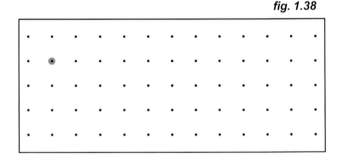

fig. 1.38

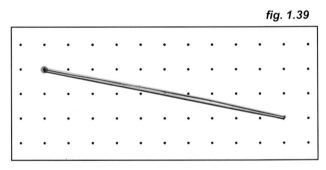

fig. 1.39

These are important factors in the creation of a composition, but they are obviously not the only ones. There might be a shot where the two characters are very close together, yelling at each other face-to-face. Although there is no "stretching" between the two key points of the shot (in this case, their eyes), the tension and drama will still be expressed through their faces, their menacing proximity to one another, and even the angles and chaotic folds of their clothing will have a say.

fig. 1.40

fig. 1.41

fig. 1.42

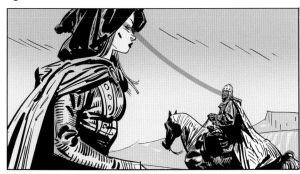

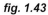

fig. 1.43

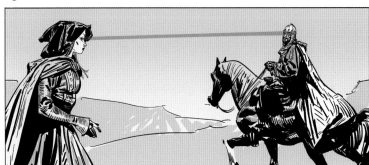

Below are some vertical formats illustrating the **lines of tension**, as we keep exploring this elastic-band idea.

Fig. 1.44: Shows an even triangle between key points that doesn't push or stretch its sides and angles much.

Fig. 1.45: The same three cowboys in a down shot. This time we have "stretched the band" a lot, and the greater distances and dynamics add a lot to the drama.

Fig. 1.46: A diagonal line crosses from the dirigible top-left to the spectators bottom-right, creating a vibrant and elegant dynamic.

Fig. 1.47: The zeppelin is much lower, closer to the crowd, which makes for a heavier and more compact image while reducing the "stretching tension" between the two main elements in the scene.

Fig. 1.48: The same shot, but pushed upward as a single unit so that it creates pressure toward the top of the frame and a release area at the bottom, increasing the intensity of drama.

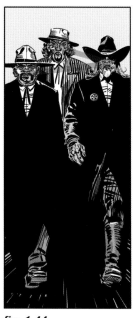

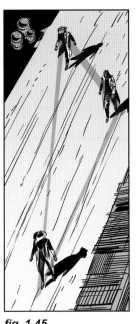

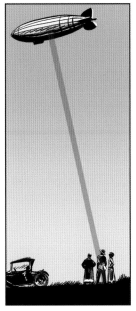

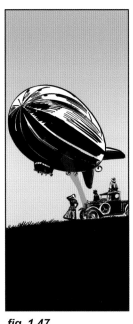

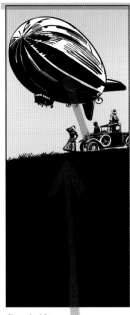

fig. 1.44 fig. 1.45 fig. 1.46 fig. 1.47 fig. 1.48

fig. 1.49

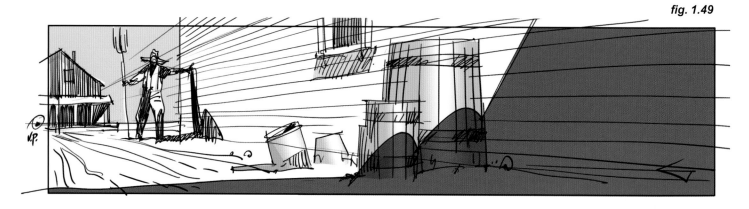

Fig. 1.49: Most compositions in this chapter are based on an extreme, unusual positioning of the main character. In these circumstances it can be difficult to work out a convincing layout. That is when we might consider using strong cast shadows or similar devices that reduce the focus area in the scene to a more limited portion by essentially cropping the image.

Figs. 1.50 and 1.51: Two simplified versions of the same sketch, with the shadow-induced cropping indicated in red.

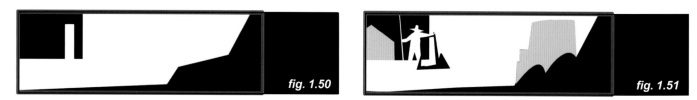

fig. 1.50

fig. 1.51

Fig. 1.52: If we decided to use the full width of the frame and move the barrels all the way to the right, that would leave a lot of purposeless blank real estate in the middle (striped area, fig. 1.53). The barrels are so cornered that visually they feel too secondary to mean anything substantial to the scene, therefore losing any real focus of the action in the shot.

Figs. 1.54 and 1.55: If widening the frame is an option (for a graphic novel panel as opposed to a fixed screen format), then we could include more drums so that they intrude on the blank middle space and become proportionally more important and significant.

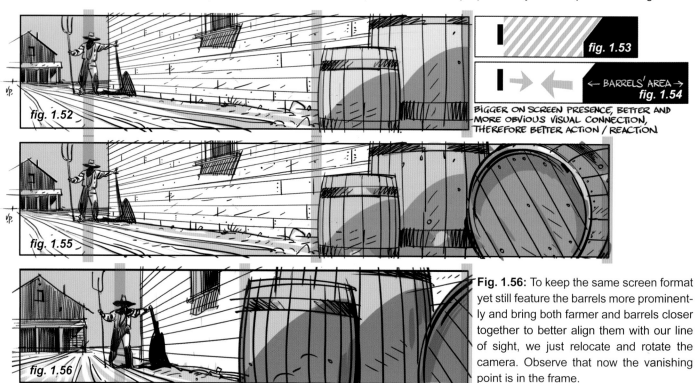

fig. 1.53

← BARRELS' AREA →
fig. 1.54

BIGGER ON SCREEN PRESENCE, BETTER AND MORE OBVIOUS VISUAL CONNECTION, THEREFORE BETTER ACTION / REACTION

fig. 1.52

fig. 1.55

fig. 1.56

Fig. 1.56: To keep the same screen format yet still feature the barrels more prominently and bring both farmer and barrels closer together to better align them with our line of sight, we just relocate and rotate the camera. Observe that now the vanishing point is in the frame.

CAMERA ROTATION

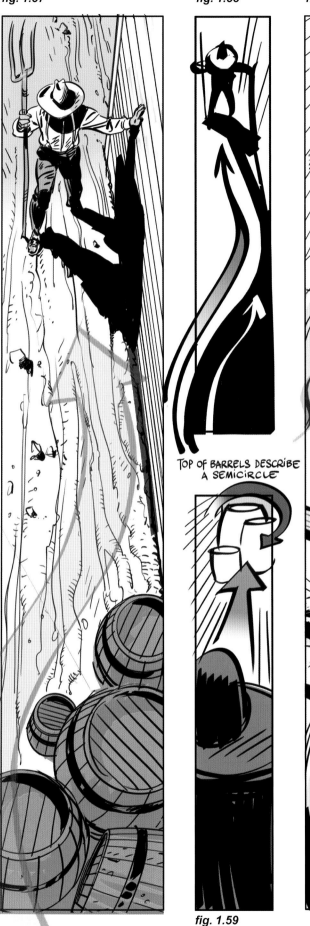

fig. 1.57

fig. 1.58

fig. 1.60

TOP OF BARRELS DESCRIBE A SEMICIRCLE

fig. 1.59

Fig. 1.57: Same scenario, adapted to an extreme, vertical format. It is still important to create actions–reactions between the two main elements: the farmer and the barrels.

Fig. 1.58: Observe how the position of the barrels in this shot creates, together with the side wall, an "S" shape that describes a motion toward the farmer. This creates a dynamic interaction between them, while using the vertical format. It is like leaving a window open to let the breeze come in and flow freely and naturally as it adapts and reacts to the shape of the room.

Fig. 1.59: In this over-the-head shot, we use the vertical format to describe a power struggle between the farmer's imposing shape in the foreground and the barrels cornered at the end of the perspective, quite close to the frame's edge. The overall composition of the top of the barrels takes the shape of a semi-circle. This redirects the eye back into the scene. A different shape might lead the eye out of the frame.

Fig. 1.60: The imbalance of the size difference is what makes the farmer seem imposing compared to the distant barrels. The breathing area—or space above the barrels—helps retain the graphic silhouette of the casks' tops. Notice that the top of the hat has been included almost entirely in the shot, to better help read its silhouette (in orange) as to what it is. The more we crop off an unusual shape like this, the less recognizable it becomes—as, in this case, a hat.

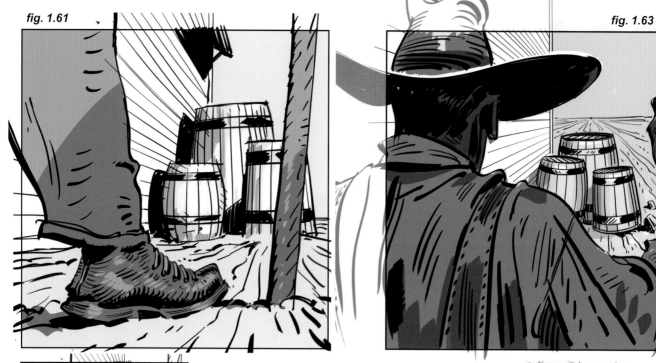

fig. 1.61

fig. 1.63

fig. 1.62

Fig. 1.61: A concentric composition can be an interesting approach to a square format, where certain elements (the leg, boot and pitchfork) frame the center of attention (the barrels).

Fig. 1.62: Use of the rule of thirds (to be discussed fully in chapter 7) where the leg, boot and base of the pitchfork dominate the darker L-shaped area, leaving the remaining space to the barrels.

Fig. 1.63: Raising the camera creates an over-the-shoulder shot applying a concentric composition to the scene. The framing elements are the farmer's head, shoulder and arm.

In cases like this it is helpful to extend the drawing of the main subject beyond the limits of the frame (line in grey) to make sure whatever shows in the frame makes proportional and anatomical sense.

Figs. 1.64 and 1.65: Applying the rule of thirds.

Fig. 1.66: The camera is behind the barrels now, looking toward the farmer, almost straight-on (on axis). This low angle, and the perspective-induced size differential between the two subjects, enhances the intensity of the visual dialogue between them.

Fig. 1.67: Abiding by the rule of thirds, the barrels in the foreground take up about two-thirds of the shot.

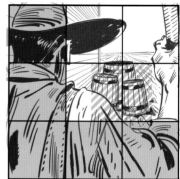

fig. 1.64

fig. 1.65

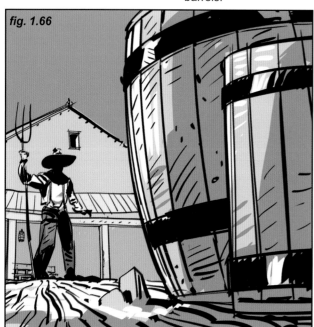

fig. 1.66

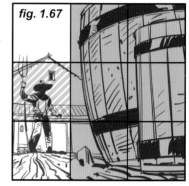

fig. 1.67

COMPOSITION FLOW
— THE BASICS

Until now we have seen a maximum of two elements within a frame: one character plus clouds, the sun, a group of barrels, another character, a mountain, etc. Let's now combine many elements at once, starting with multiple characters, and make sense of them from a compositional point of view.

FROM THE GET-GO

Although the process of drawing a panel can sometimes flow straight out of our brain and brushes in an easy and natural way, it will more often involve thinking and re-thinking, doing and re-doing.

Ultimately, the combination of all of the elements (characters and environments) must work as single narrative unit, but for now, let's focus on just the characters in the scene.

One of the biggest challenges from a compositional point of view is arranging a number of characters in a way that is visually expressive, clear and compelling. Let's analyze a few examples of how to create a solid, underlying structure, as indicted by the orange arrows.

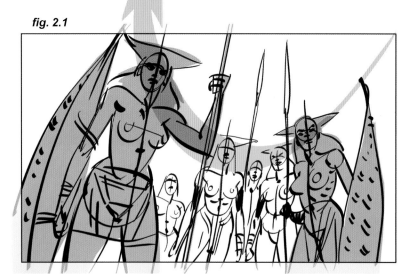

fig. 2.1

Fig. 2.1: The overall flow of this group of female warriors describes an inverted arc. The character on the far left is closer, higher and more prominent, giving the shot a clear focus and sense of visual **hierarchy** within the elements in the scene.

Fig. 2.2: The celebrity and her two bodyguards are essentially three verticals that create a solid, persistent rhythm.

Fig. 2.3: Within the chaos of the moment this zig-zag shape provides a solid structure to follow and visually hold on to.

Fig. 2.4: An extreme vertical shape like this could present a challenge in itself, but here provides a wonderful opportunity to order the elements of the scene in a flowing, dynamic and interesting way.

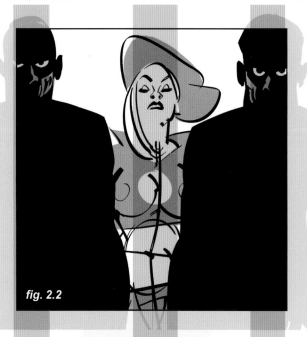

fig. 2.2

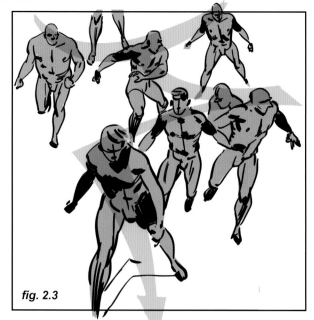

fig. 2.3

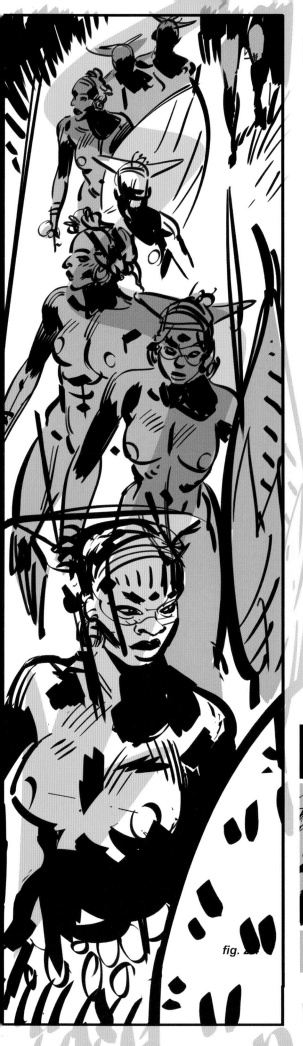

ON KEEPING A FRESH APPROACH

Oftentimes after giving a panel a first pass, we still see room for improvement or options to try that might lead to a better result. This is always healthy and recommendable; it allows us to experience more by trying alternative angles and approaches on the same idea. But keep all the versions so you can return to an earlier one if need be.

After trying multiple directions, opening that drawer where we keep our first efforts can surprise us very positively, and it's not rare to go back and use one of those rather than the more elaborate, and sometimes "overdone," stuff we eventually came up with in our search for perfection.

While working on my graphic novel *Trail of Steel: 1441 A.D.* the first thing I did was a quick layout pass for each page, making sure the compositions worked not only panel by panel, but also as full double-page spreads. At that early point the work was fast and mostly about quick masses of black and white with just the most basic details. Once I was satisfied with the established language I went ahead and cleaned up and detailed the artwork.

Figs. 2.5 and 2.6: On many occasions after finalizing the drawings, I would look back at the original quick layout and realize that part of the freshness in the execution had been lost. In these cases, I would remove the "finished" drawing and bring back the original sketch, adding only the necessary details to get the message across.

So loosen up, don't be afraid, trust your instincts, keep all versions in a drawer, look at them again after going full circle. No effort is wasted and it is all part of the daily learning process.

Showing the elements in a composition simply as backlit silhouettes can help us visualize how their most basic shapes combine as forms of expression. Still, we will need to make sure they are all part of a basic choreography that "dances the scene away" with a coordinated flow and/or breaking points as needed, literally connecting all the dots in a suggestive and meaningful manner. Sometimes the narrative requires that visual flow be interrupted and changed into a different rhythm to emphasize a sense of drama or transformation.

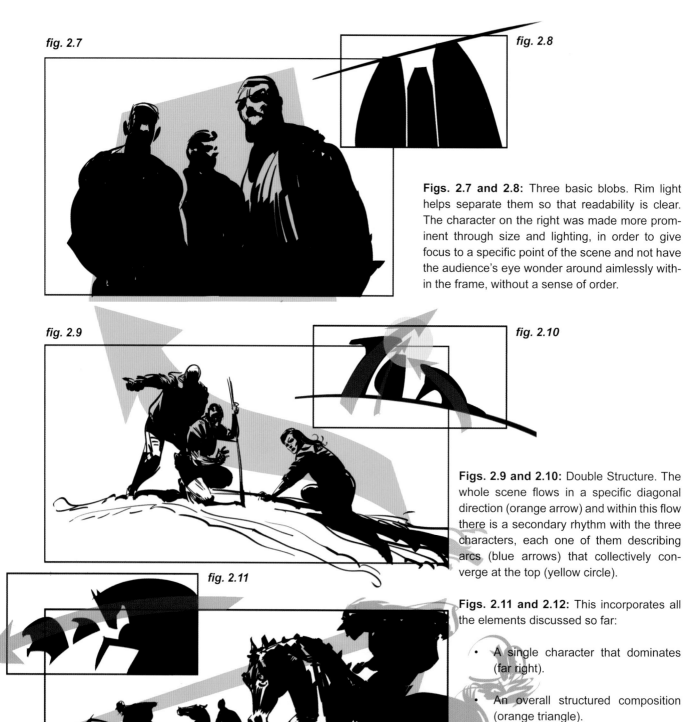

fig. 2.7

fig. 2.8

Figs. 2.7 and 2.8: Three basic blobs. Rim light helps separate them so that readability is clear. The character on the right was made more prominent through size and lighting, in order to give focus to a specific point of the scene and not have the audience's eye wonder around aimlessly within the frame, without a sense of order.

fig. 2.9

fig. 2.10

Figs. 2.9 and 2.10: Double Structure. The whole scene flows in a specific diagonal direction (orange arrow) and within this flow there is a secondary rhythm with the three characters, each one of them describing arcs (blue arrows) that collectively converge at the top (yellow circle).

fig. 2.11

fig. 2.12

Figs. 2.11 and 2.12: This incorporates all the elements discussed so far:

- A single character that dominates (far right).

- An overall structured composition (orange triangle).

- A flow of characters (three horses and riders) that forms a straight line from right to left (blue arrow), in the direction of their gallops.

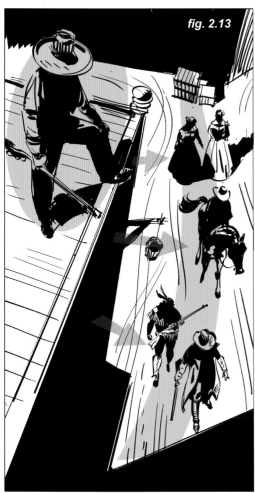

fig. 2.13

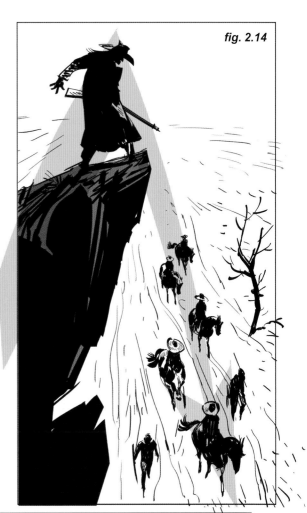

fig. 2.14

These two panels are similar in composition, theme and panel format. The differences are mainly in the dynamics and the flow.

Fig. 2.13: Essentially, an oval shape (gunman on roof) "pushes away" (blue arrows) a line of walking characters, slightly arched due to this visual pressure. This setup gives the rooftop cowboy a presence that radiates domination, creating a buffer zone between him and the dominated group.

Fig. 2.14: The energy drives from the base of the foreground rock, all the way up to the cowboy's head, then suddenly drops all the way down through the posse's line. An angular A-shaped dynamic creates drama by literally reaching all the way up...and then suddenly dropping.

fig. 2.15

fig. 2.16

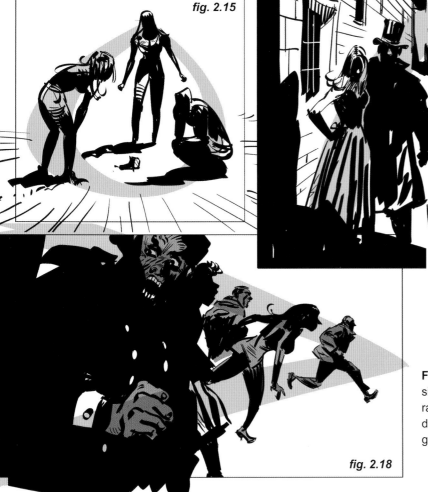

fig. 2.18

fig. 2.17

fig. 2.19

Figs. 2.15–2.19: A few mostly silhouetted, graphic compositions based on simple geometrical shapes. Inking with a rather thick brush does not leave much room for needless details, and remember, 99% of the time simplification is great.

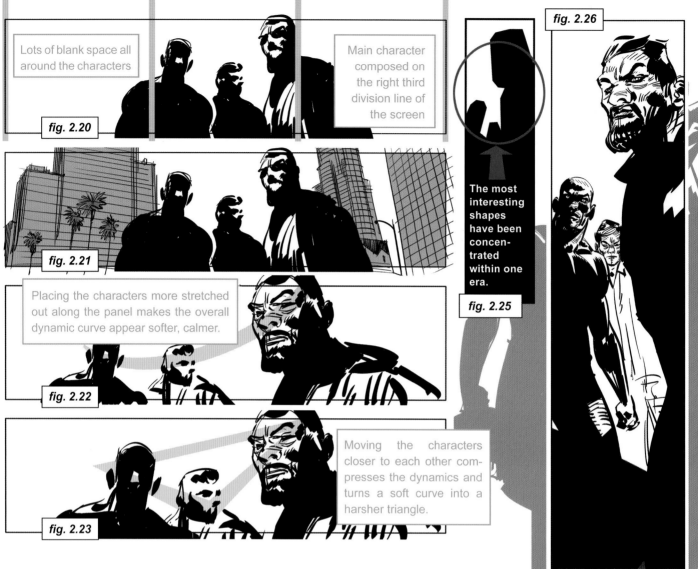

Lots of blank space all around the characters

fig. 2.20

Main character composed on the right third division line of the screen

fig. 2.21

Placing the characters more stretched out along the panel makes the overall dynamic curve appear softer, calmer.

fig. 2.22

Moving the characters closer to each other compresses the dynamics and turns a soft curve into a harsher triangle.

fig. 2.23

fig. 2.26

The most interesting shapes have been concentrated within one era.

fig. 2.25

fig. 2.24

fig. 2.27

Let's explore how some of these scenes would be framed within both the panoramic and vertical versions of a 4:1 ratio.

Fig. 2.20: Here is a cropped section of the drawing from fig. 2.7, placed into a horizontal 4:1 frame, leaving out the lower area that showed the less important information. To keep as much of the original characters as possible, a minimum of air was left above their heads, which is why the top of the main character's head is slightly cropped.

Fig. 2.21: Unless there is a narrative purpose for the amount of dead space around them, it is better to create a sense of depth, geography and location by adding an environment.

Fig. 2.24: This early sketch shows a vertically compressed triangle that helps recompose the characters into this narrow format. The difference between the triangle in fig. 2.23 and this one illustrates an exercise on "stretching and reshaping the elastic band" we were talking about before.

Fig. 2.26: For shots like this, always draw the full characters to avoid distortions and anatomical mistakes. This makes for a more believable look once the frame is cropped.

Fig. 2.27: Again, to provide context the characters were lowered in the frame, creating a void at the top that was filled with background buildings.

Here are more examples of changing the dynamics and tone of a moment by reframing and therefore recomposing the shot. Refer back to fig. 2.9 on page 028 to see the basic silhouette.

Fig. 2.28: Let's see how this large horizontal format can be used to our advantage. Surrounding them with empty space to highlight their isolation is a great candidate. To do this, the size of the trio was reduced so that the dead space around them **did not become a visual liability but rather a part of their story.** The characters were kept large enough that their body language is still readable.

The group has been composed roughly by thirds, but more importantly, looking at the use of the space and dynamics, the energy of our game field has been played to create a swift motion (orange arrow) that goes from the foreground rocks to the castaways in a slight left-to-right diagonal. Then the energy is suddenly redirected to the left by the pointing finger of the standing character. His body is following a slight left-to-right diagonal, so his shoulder actually acts as a **turning point** (yellow), and that's where the flow's direction suddenly reverses.

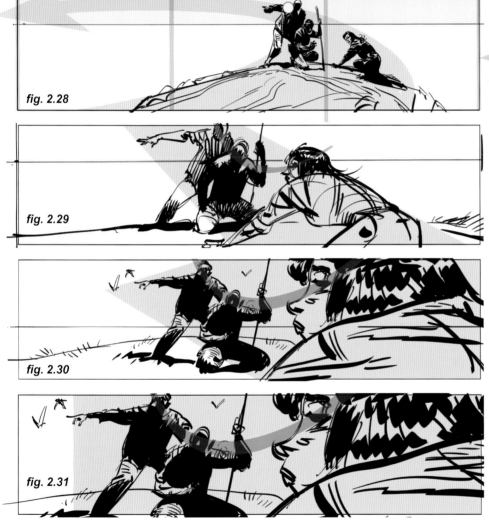

fig. 2.28

fig. 2.29

fig. 2.30

fig. 2.31

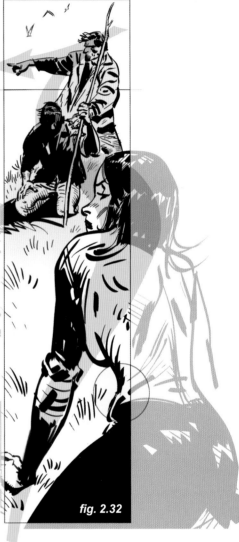

fig. 2.32

Figs. 2.29, 2.30, and 2.31: The camera is in a new position and was **rotated around.** The three characters almost align and we get a concentrated view of their expressions (similar to the farmer vs. barrels, fig. 1.58, page 022).

Dynamics change as we close in:

Fig. 2.29 follows a diagonal created by the three lined-up characters,

Fig. 2.30 further emphasizes the depth between the dramatic foreground and the two background characters.

Fig. 2.31 works essentially as a rectangular block, right on the characters' drama and expressions.

Fig. 2.32: With her body bending at the waist, it is important to show not only her shoulder and thigh, but also part of the waist (yellow) as it visually connects the two, eliminating any confusion.

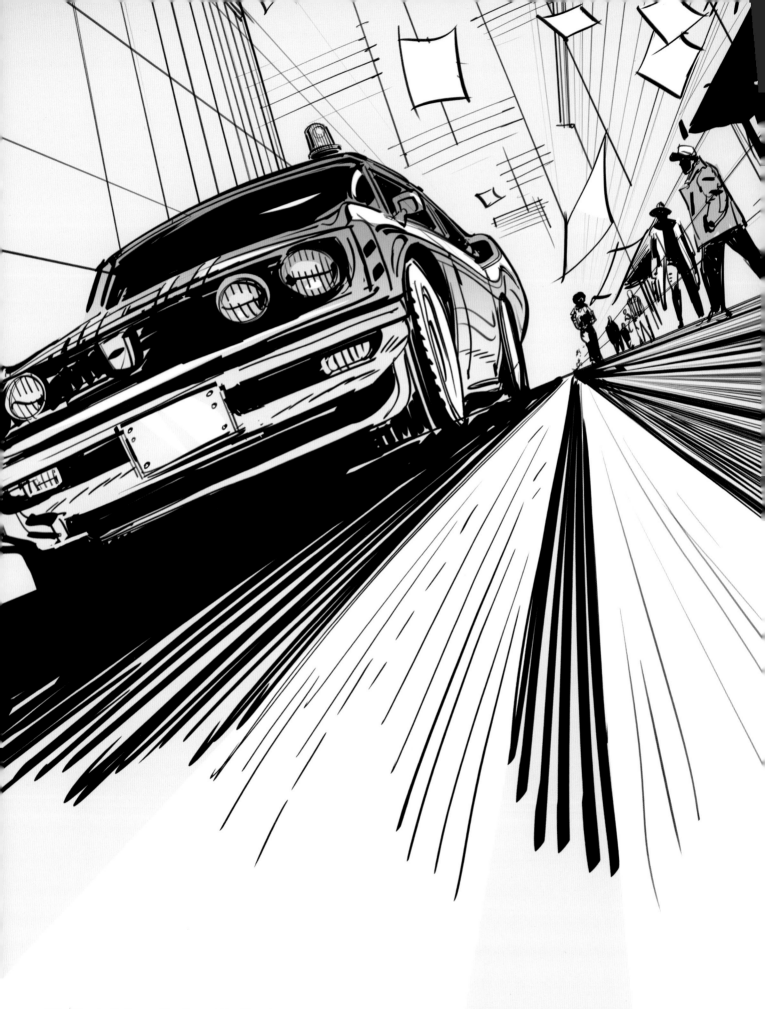

COMPOSITION FLOW - A FUN EXERCISE

THE SPIRIT OF A MEANINGFUL AND NATURAL FLOW

There are many ways to approach a new composition. Most important is to find a way to inject meaning. One must understand and believe in the choices.

The previous chapters discussed the bare essentials of an image, starting with little thumbnails that show both the energy dynamics and the light and shadow basic structure of each shot. Now let's talk about ways to ensure these dynamics are solid.

One way to do this is to think about dance choreography, which at its essence entails movement, and the spirit behind it. There are two ways to approach this. One is mechanical, like a request to "stretch your arm up in the air and twirl your hand and wrist." That's fine, but devoid of meaning or intention. If instead the choreographer asks you to "reach up for a fruit hanging from a tree, grab it and gracefully bring it down to a basket," that's different. The overall movement will be the same but **now we have a story to tell.** We have a move that we have probably done before, are familiar with, means something to us and gives a purpose to this otherwise mechanical stretching of our arm. Just as asking us to "lift your wrist and put it in front of your face" is quite different from "suddenly lift your wrist and realize you are late the moment you glance at your watch." Now there is a purpose and a story.

A FUN EXERCISE / THROWING BASEBALLS AROUND

Once we have a general idea of the kind of dynamics needed for a shot, it helps to link it to something we understand and feel connected to, something we find credible and that makes sense to us. It is always easier to create a dramatic interpretation when we understand the purpose.

The point is to infuse this concept into our compositional choreography, representing an action that might therefore spark a reaction. Things will become vibrant and **a meaningful and structured flow** that follows the physics of an emotional moment will carry us through the scene.

Fig. 3.1: As inspiration for this move, let's say we decide to grab something in the air as it comes flying at us, a baseball for example. (**A**) we follow it; (**B**) we grab it; (**C**) in the same circular motion we bring it down to thigh-level, then; (**D**) we stretch our arm in the opposite direction while throwing the ball away fast. This would read like a number "2" in midair. As an action we can easily relate to, let's make this our inspiration and base the next composition on the shape of a 2.

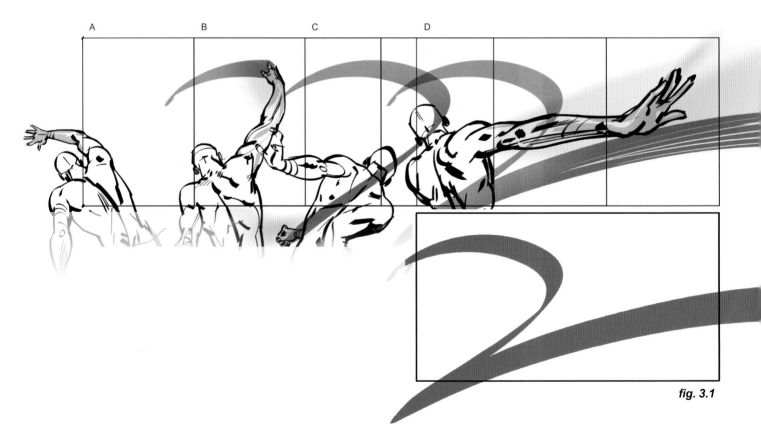

fig. 3.1

The main dramatic element here is the twist or change in the middle **(point of inflection)** as the flow radically diverts from one type of path (semicircular, from top to bottom) to another (almost-straight diagonal, up and to the right). Yet everything remains linked by a coherent gesture, based on a plausible, real-life move. So, can this work for a **western landscape?** An urban **car chase?** A moment at a **wedding?** ...And **in a variety of screen formats?**

Let's look at it with a 1.85:1 format **in both its landscape and vertical versions.**

fig. 3.2

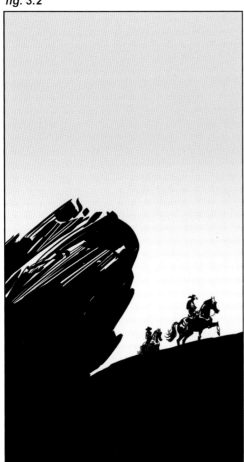

fig. 3.3

Figs. 3.2 and 3.3: This uses the simplicity of the basic idea to depict the effort and challenge of the uphill journey in a particularly dry, desert-like landscape. This is a moment that requires energy on the part of the characters, which is visually expressed by the point of inflection—the change on the energy's direction—between the lines of action and reaction. Remember, change equals drama.

Fig. 3.4: In order to maximize the visual energy of the shot, the cowboys ride away from the claustrophobia of the oppressive rock and toward the open, expansive space.

fig. 3.4

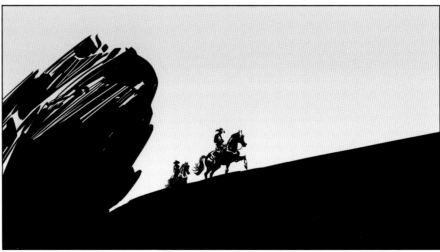

fig. 3.5

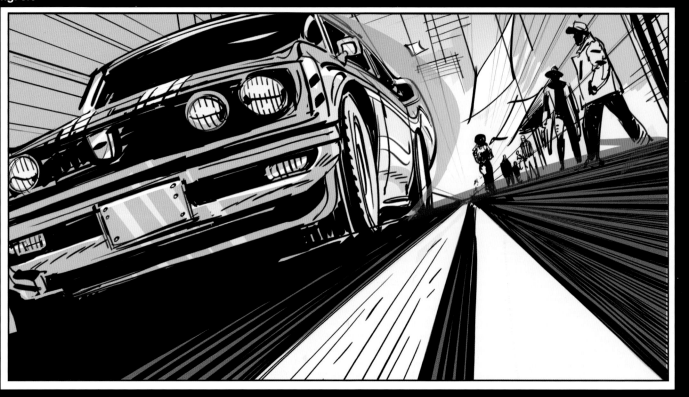

fig. 3.6

Now for the car chase.

Fig. 3.5: The camera position is very low, right on the street's pavement in order to maximize a dynamic, wide-angle lens effect. This allows us to play the far end of the street as a straight line that turns into a shot of energy traveling diagonally up and to the right, and off the panel.

This diagonal (red arrow) is cut a bit short compared to the cowboys in the desert shot (fig. 3.4) since it is more important to feature the car prominently as the focus of the story moment, along with an overall sense of dramatic speed.

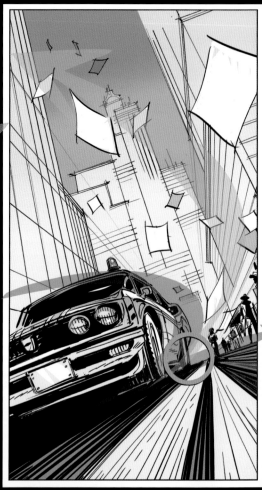

fig. 3.7

fig. 3.8

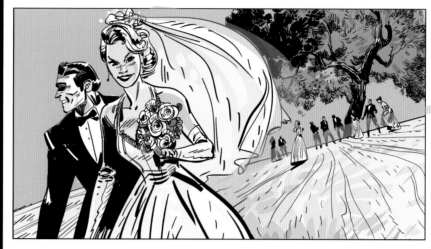

Fig. 3.6: If the diagonal (in red) were to be featured more prominently, that would require moving the frame to the right. The shot would become more about the overall street scene, the characters walking by and the buildings, turning the cars into more secondary subjects. **So now it's more about the crowd's reaction to the chase than about the chase itself.**

Fig. 3.7: This version adapts the action and composition to a **vertical aspect ratio.** The car is placed in the lower third of the frame, as centering it would kill the overall dynamism.

But this created a problem: The top two-thirds of the frame didn't do anything for the shot; it was like a dead space that got too much attention **yet offered nothing to the moment.**

A solution was to add papers and trash flying around (as a direct consequence of the cars' speed). This increases the chaos of the moment and gives a narrative purpose to that otherwise meaningless space at the top.

The flying trash emphasizes the dynamics by describing a curve **that starts at the point of inflection** (circled in blue). In fig. 3.6 the trash on the pavement (orange arrow) also plays along with the shot by being composed in the same direction as the red diagonal.

When I mentioned a wedding on page 035 it was a totally random thought. I had no clue how I was going to resolve it as the theme of a composition in the shape of a 2. But I knew there would be a way. Ninety-nine percent of the time... there is a way.

Figs. 3.8 and 3.9: Here are two options framed by the vertical and horizontal version of a 1.85:1 frame.

Fig. 3.10: A detail of the distant crowd attending the celebration.

Again, it's about motion and a sense of natural flow. Create a rhythm and then, in some cases, break it at a point of inflection to add drama.

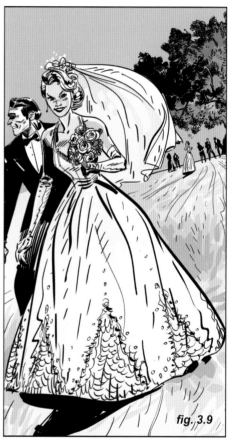

fig. 3.9

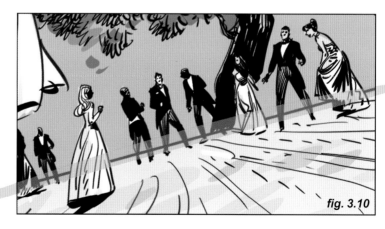

fig. 3.10

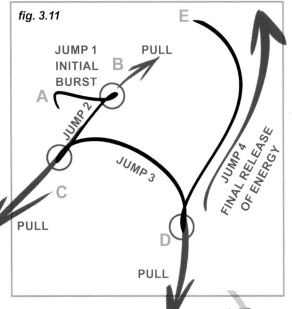

fig. 3.11

Fig. 3.11: This zig-zag line is based on the idea of a squirrel jumping from branch to branch and tree to tree, and will serve as a guide for the next two compositions in a 2.35:1 frame format, in both horizontal and vertical versions.

Let's analyze the line: The squirrel jumps four times, each in a completely new direction which makes the line eventful as opposed to monotonous. Also, **each jump** increases in length, and at the end of each one—that is, **at each turning point** (red circles)—the lines are strongly pulled way down (red arrows) before bouncing to the next motion. Finally, after a constant downward direction (from **A** to **D**) the "conflict" of this line is finally resolved in a sudden upward move that shoots all the way up to **E,** much higher than the original point **A.**

Fig. 3.12: This line applied to a platoon in the jungle.

Fig. 3.13: In this detail, the **turning points** are visually emphasized by suddenly bringing the line of soldiers down and off the lower edge of the frame in a strong way (red arrow) before bouncing back in a firm upward direction (orange arrow).

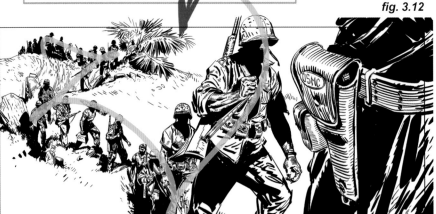

fig. 3.12

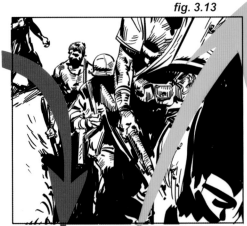

fig. 3.13

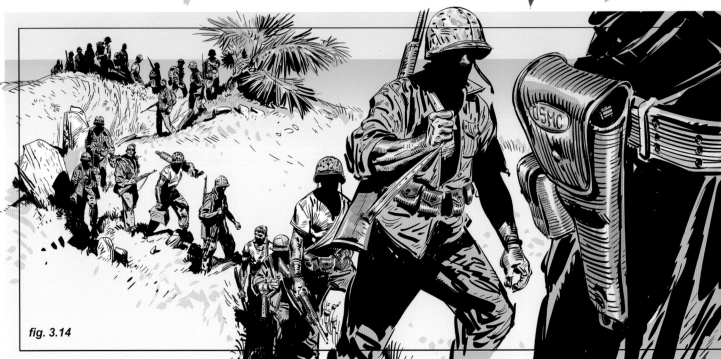

fig. 3.14

fig. 3.15

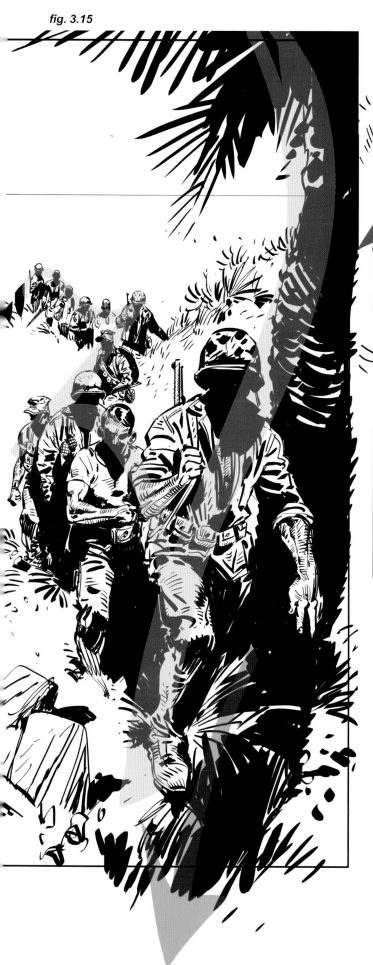

fig. 3.16

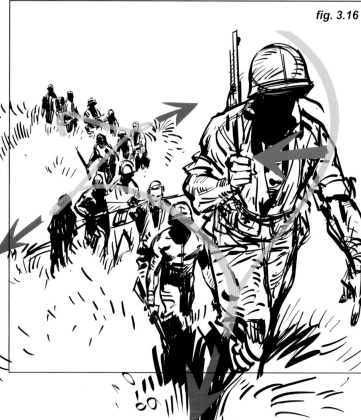

fig. 3.17

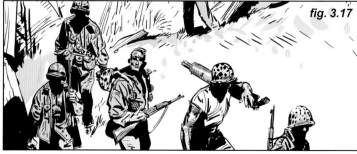

Fig. 3.15: The Z-shaped orange line was compressed horizontally in order to fit this vertical 2.35:1 frame. In order to emphasize the final burst of energy (line **D–E** in fig. 3.11) the dark shape of a palm tree's trunk was added on the right. Again, the final turning point (**D**) was accentuated by the foreground soldier's boot stomping the foliage, which then continues beyond the bottom of the frame (red arrow) so that we can shoot up all the way to **E** (top of the palm tree) in a very powerful way.

Fig. 3.16: To accommodate the square format, the foreground character was moved left of the final **D–E** line, closer to the line of soldiers behind him (orange arrow). Also the "pulling effect" (red arrows) has been emphasized to state each one of the turning points more clearly.

Fig. 3.17: To compensate for the extreme zig-zag nature of the line, most soldiers—whether they travel left or right—tend to face forward, toward the camera. This connects the four sections of the line so that the soldiers appear to travel with a common goal.

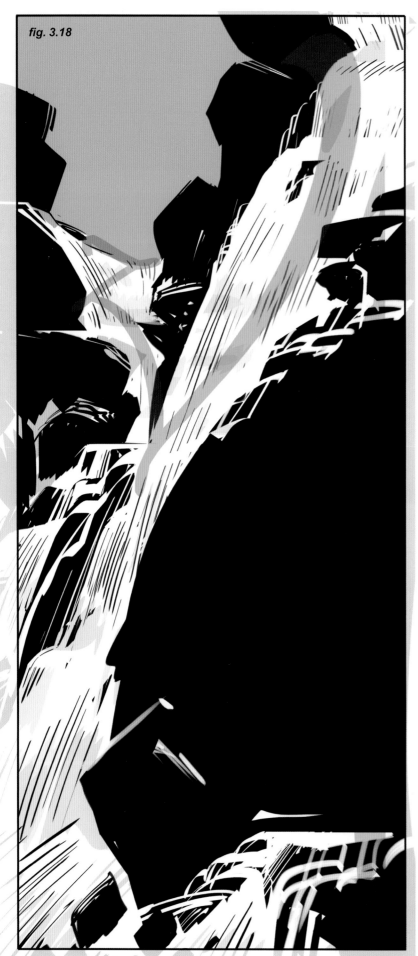

fig. 3.18

Figs. 3.18, 3.22, and 3.25: Three compositions of a waterfall in three different aspect ratios, 2.35:1 vertical, 2.35:1 horizontal and 1:1 square, utilize the same dynamics (in red, slightly stretched vertically) as the previous shot: "Marines in the Pacific."

Again, the key moment is the turning point (the lowest point of the red line) where the entire dynamic of the composition bounces off the initial downward direction to take an unexpected upward turn.

Figs. 3.19 and 3.20: The inflection point (circled in red) is placed within the bottom half of the frame so that there is enough space above to redirect the shot's energy.

Figs. 3.18 and 3.21: The turning point or point of reaction is in the vertical center of the frame. The tall format allows room to see more of the waterfall going down.

Figs. 3.21, 3.23, and 3.24: The overall silhouette of the water stream (yellow) has been largely simplified.

In a scene like this there can be a lot going on, waterfall, rocks, water splashes... A graphic and simple approach is best in order to get the visual message across.

fig. 3.19

fig. 3.20

fig. 3.22

fig. 3.21

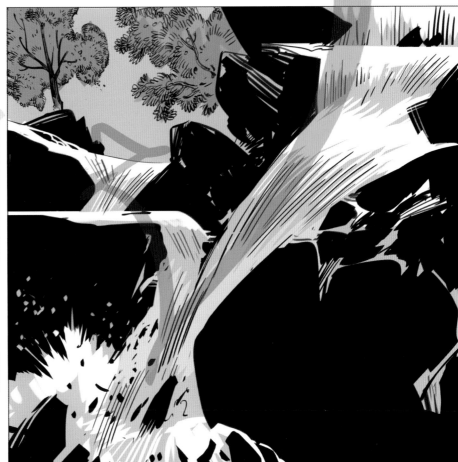

fig. 3.23

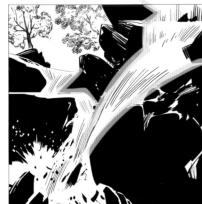

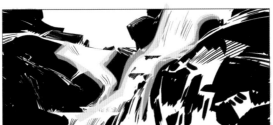

fig. 3.24

fig. 3.25

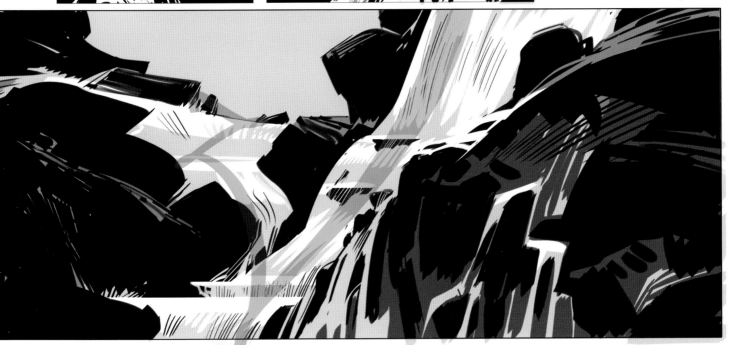

Fig. 3.26: As a practical exercise proposal, here are a number of dynamic lines that may inspire you to draw scenes based on them. These lines were created freely and without an actual scene or specific action in mind. Let them, and any others you might come up with, serve as a starting point for a themed composition in any of the panel formats discussed.

The scenes could be as various as a visit to the Sagrada Familia church, a football match seen from the point of view of the players (or from the crowd's), maybe a tropical storm, or World War II airplanes dogfighting over Italy. **Whatever comes to mind.** So go ahead, get to drawing, and have fun!

COMPOSITION FLOW
—
DEALING WITH CROWDS

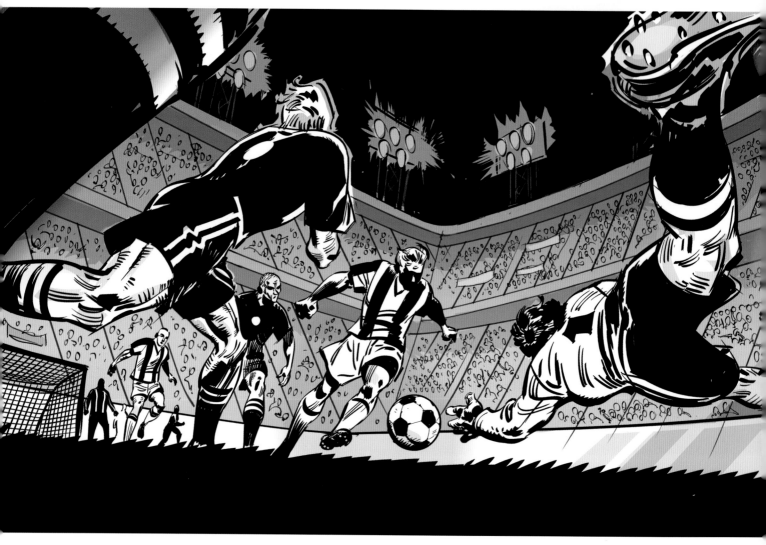

Let's now increase the scope with **more elements in play:** A soccer game, at the moment a striker has positioned himself in front of the opposing goal...he shoots, surrounded by a crowd in a cathedral-size stadium.

Fig. 4.1: A widescreen format is perfect to show **an epic take on the full moment,** as opposed to, for example, a close-up shot of the faces which would show the individual drama of the participants in the game.

The elements here are: **players** from the two competing teams, a **ball,** a big **stadium** in the background and a large, roaring **crowd.** For starters we'll need to make sure we can distinguish, in a split second, who belongs to which team by depicting very distinctive shirts. Otherwise we will start guessing and lose the tension of the moment. Establishing who's who clarifies the game strategy of the moment: two attackers (in striped shirts) are surrounded by defenders (in dark shirts with a white circle). The goalkeeper jumps in for the ball. This is further clarified by the way we have staged the composition, analyzed in the following thumbnails:

Fig. 4.2: The heads of the main players conform to a tilted oval (blue), while they all run, or their bodies point (orange arrows), toward the ball (red).

Fig. 4.3: The heads of the two players to the left, plus the torso and leg of the goalie, create an additional circle (black) that further focuses attention on the ball as the catalyst of the action. The corner of the stadium's structure (blue) also points toward the ball.

Fig. 4.4: Now for the general action–reaction dynamics: the foreground leg of the goalie describes a curved line (yellow arrow) that seems to cause a reaction on the defender to his right (black arrow), who appears to be propelled back by the goalie's body motion, despite the fact that both actions are actually independent. Finally, the main action is framed within the central third of the screen and both the attacker and the ball are positioned exactly on the left-third division line of the frame.

fig. 4.1

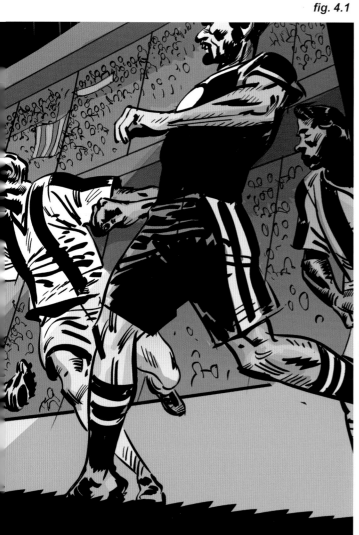

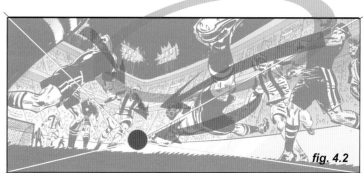

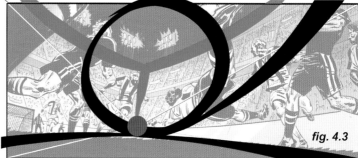

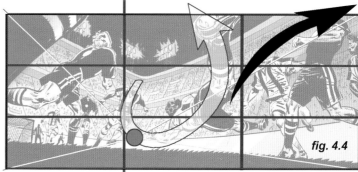

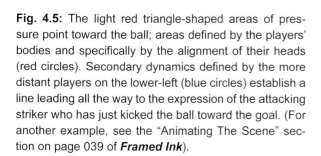

Fig. 4.5: The light red triangle-shaped areas of pressure point toward the ball; areas defined by the players' bodies and specifically by the alignment of their heads (red circles). Secondary dynamics defined by the more distant players on the lower-left (blue circles) establish a line leading all the way to the expression of the attacking striker who has just kicked the ball toward the goal. (For another example, see the "Animating The Scene" section on page 039 of *Framed Ink*).

Fig. 4.6: Here are two versions (wider and tighter) of a 2.35:1 frame. Observe that in both sizes, the ball remains in the exact same relative position and everything else revolves around it as the catalyst for this action. (For more on this, see the "Cutting in" example on page 026 of *Framed Ink*).

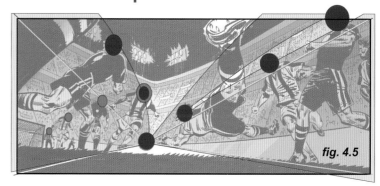

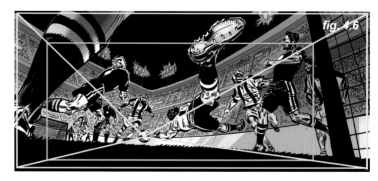

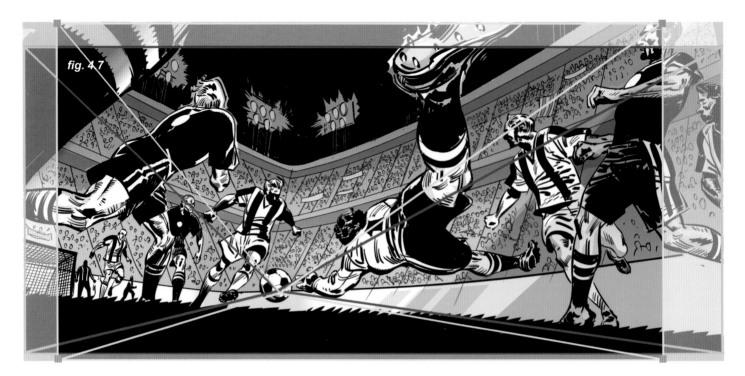

Fig. 4.7: To wrap up this shot's options with the horizontal format, here is the exact same composition repurposed for a 1.85:1 aspect ratio (yellow frame). Again, compared to 2.35:1 (red frame) the football stays in the same relative position as the center of the action. This new shot basically crops the old one at the sides, removing information that was not essential, and adds just a notch at the top and bottom. (See also Chapter 5, page 055).

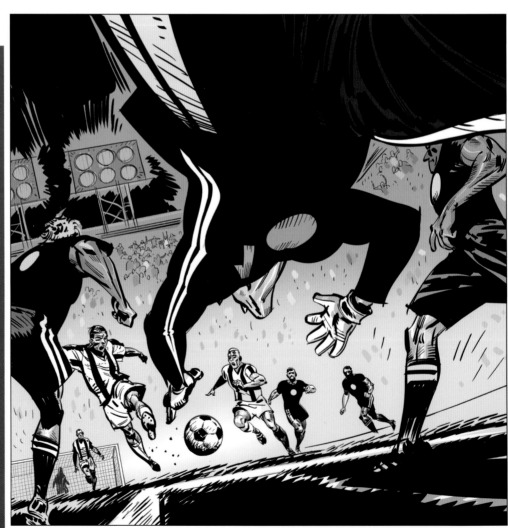

Fig. 4.8: The square (1:1) version of this shot will, given the nature of this aspect ratio, need to focus on a smaller area of the action.

Remember, there are no good or bad formats. Each provides a different way to work around and focus on a story moment. The 2.35 and 1.85 formats **allowed us to play with the epic environment of a crowded stadium as part of the shot's narrative.** Now, limited to a narrower space, the focus shifts to **the action itself between the field players and the goalie.**

Let's see how to break down this square composition into multiple factors and elements.

fig. 4.8

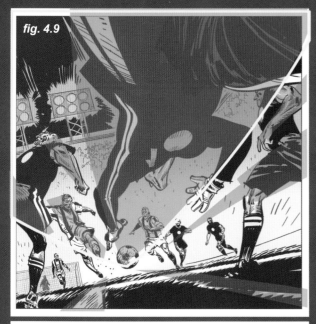

Fig. 4.9: All visual pressure is put on the ball. The triangular dark mass that is the goalkeeper jumping into the shot from the top is like an arrowhead pointing at it. Within this dark mass, the double stripe pattern in white is yet another element directing the eye toward the ball.

Same with the arms, legs and overall body shapes as signaled in red; they all contribute to the same message.

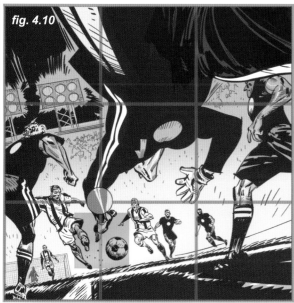

Fig. 4.10: Dividing the frame into thirds, the core of the action is located on and around the left-third division line. Still, this action area (red square) is positioned toward the lowest part of the shot.

In a purely "by thirds" composition, this action would appear on the actual intersection of the left third and lower third (yellow circle), yet sometimes a solution like this can seem too balanced, too conventional.

It is always a personal choice, but it is definitely OK to go more extreme when it comes to giving that extra push to the action and dynamics. Sometimes even composing by fourths, rather than thirds, can be a great and exciting solution, as will be explored more in Chapter 7.

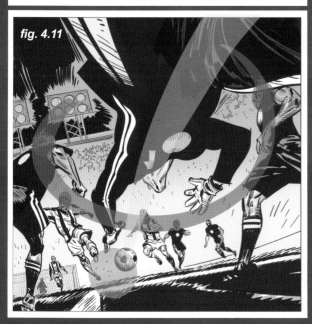

Fig. 4.11: Looking at the underlying structure of this composition, the oval defined by the field players' heads helps create a sense of uninterrupted flow in the moment, only to be pierced by the incoming figure of the diving goalkeeper.

Normally, **bringing the camera very low supports a strong sense of dynamics** by having most of the panel dedicated to action, versus an area of grass that, other than the important white markings on it pointing toward the center of focus (green), doesn't add much to the energy such a scene needs to communicate.

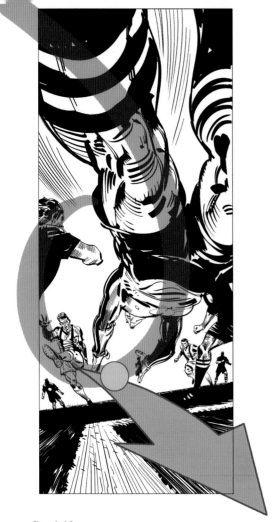

fig. 4.13

By using the 2.35:1 aspect ratio in its **vertical** format, just like in the previous examples these shots become about the action and the moment in the game, and the players involved in it.

Fig. 4.12: The spine of this shot is definitely the **strong line of tension** (yellow) that stretches all the way from the goalie's (offscreen) foot to the ball, facilitated by the very low and dramatic positioning of the camera that puts the horizon line well below the lower-third division line. The top two-thirds of the frame is devoid of too many elements (crowd, etc.) which would potentially clutter and confuse the moment. That area is simply about the goalie, a solid framing element that points toward the ball and the attacker kicking it.

Fig. 4.13: This "inverted 9" dynamic gives flow and continuity to the whole shot. Also, where the ball is (blue dot) represents the break-off point **where the action changes direction** from the motion of the leg to the trajectory of the ball.

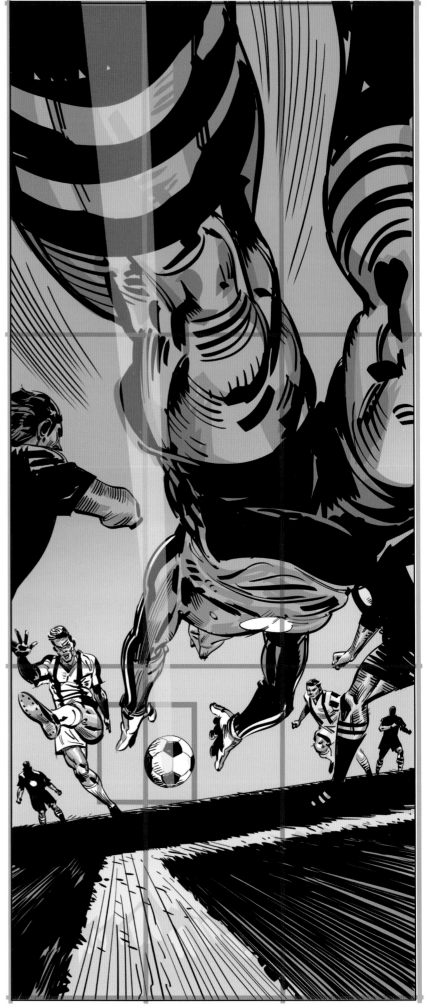

fig. 4.12

fig. 4.14

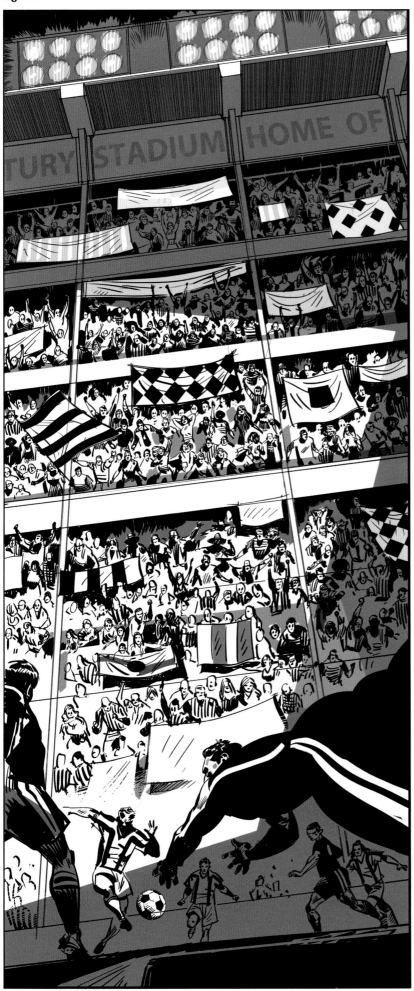

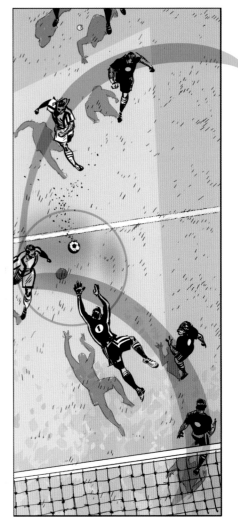

fig. 4.15

The same vertical format can be used in a new way if we decide to change the tone of the shot.

Fig. 4.14: Here is an opportunity to represent the immense pressure that a stadium full of fans puts on the players at a decisive moment in the match. The top two-thirds of the frame heaves with the weight of the screaming crowd while the players themselves are lowered to a visually under-pressure position within the panel.

Fig. 4.15: Or maybe it is not about the personal drama but about the clever and skilled strategy of the attacking players. In this case an osverhead shot makes the players and the ball appear like dots on a map. These dynamics flow in a curved path that originates at the top of the frame to where the main action happens—the area circled in blue where the ball approaches the goal and the goalie dives in—at which point it breaks to the reverse direction in order **to express the turning point of the story.**

THE CASE OF THE MEDIEVAL BATTLE

When the number of elements in a scene starts to grow, it can feel like trying to juggle more and more balls at the same time. In this case, **the best solution to such complexity is a very simple underlying structure,** so create a clear flight plan and do not deviate from it. Decide on a general flow of movement and locate the points of inflection that best represent the visual story of the panel.

The following pages contain a **full analysis** of the compositional ideas behind this fierce medieval battle.

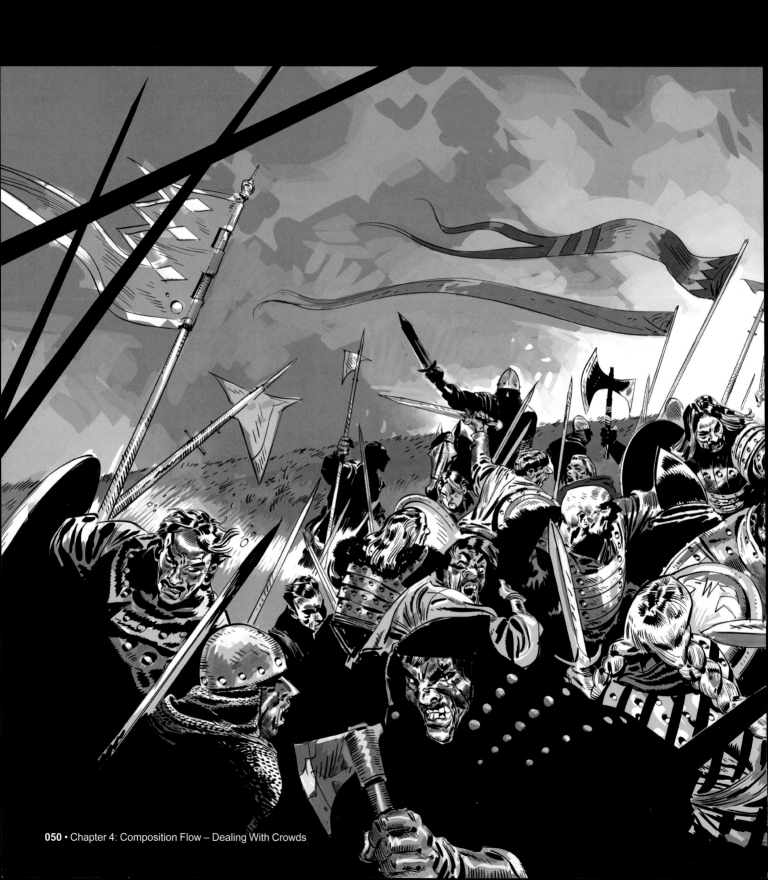

fig. 4.16

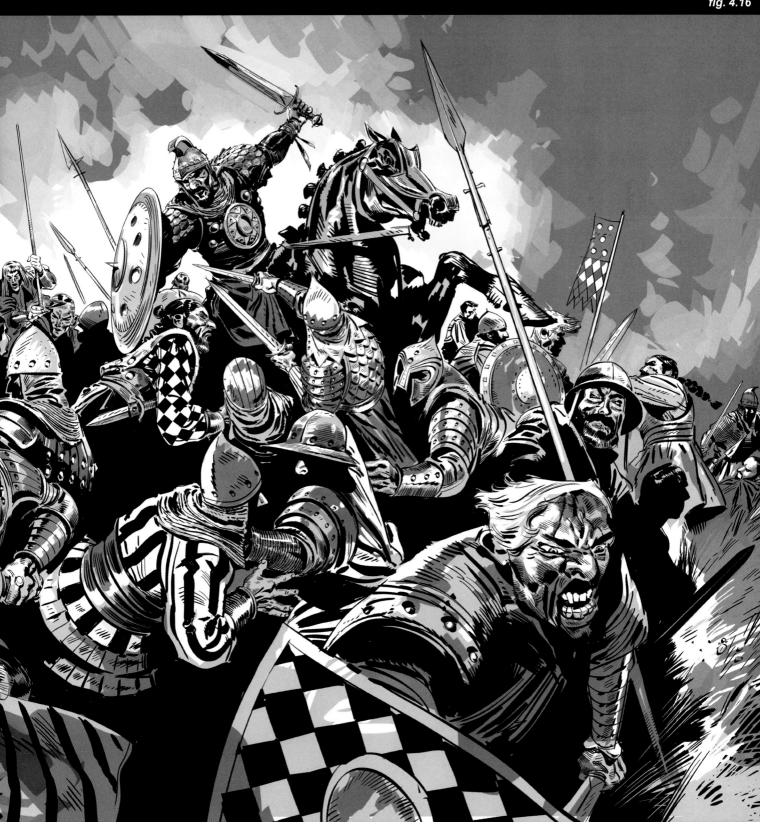

Fig. 4.17: This is the original sketch for the medieval battle. Even though it is rough, it already contains a basic philosophy for the shot, the compositional idea behind it. Sometimes such an idea is conceived before putting pen to paper, and sometimes it evolves naturally by drafting different approaches until hitting upon the one that really gets the job done.

Roller-coaster effect: The battle is designed as a push toward the abyss, and the chief warrior is at the top...

The overall positioning of the heads (purple and red circles) and their facial expressions determines the path and the flow of the whole composition

...To then suddenly stop and fall

Slow ramp-up toward the chief

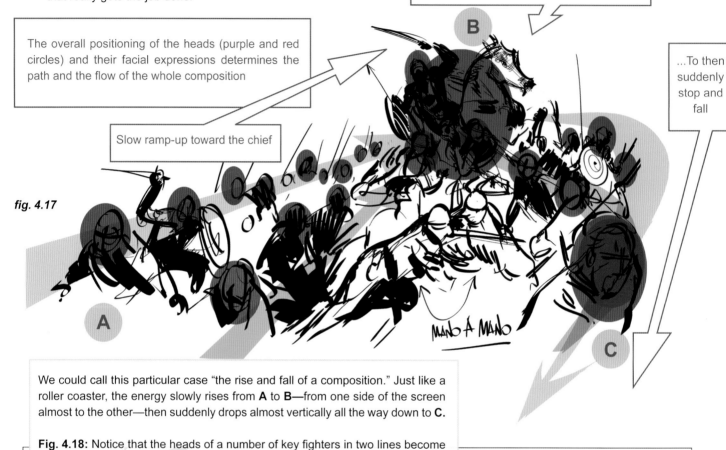

fig. 4.17

MANO A MANO

We could call this particular case "the rise and fall of a composition." Just like a roller coaster, the energy slowly rises from **A** to **B**—from one side of the screen almost to the other—then suddenly drops almost vertically all the way down to **C.**

Fig. 4.18: Notice that the heads of a number of key fighters in two lines become a visual arrow that points towards **B,** the King's head.

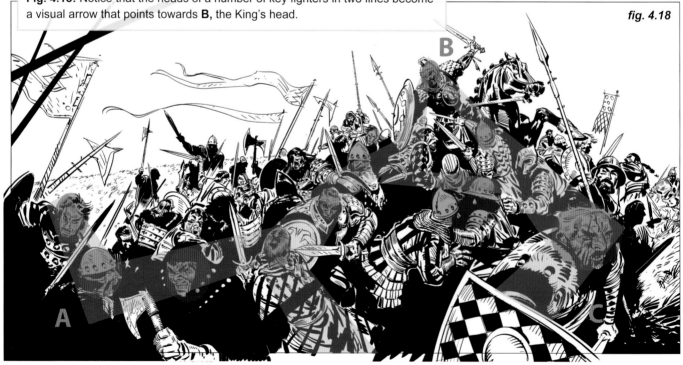

fig. 4.18

fig. 4.19

Fig. 4.19: This cropped detail illustrates how **lining up** several strongly patterned designs (clothing and shields) also helps direct the eye toward the chief at the top. It is important to use this device strategically, as having patterns all over the frame would evenly spread out our attention, losing its visual value.

Fig. 4.20: The position of the chief is at the intersection of the top-third and right-third dividing lines (red square). Also, the foreground spears (top left, yellow) help frame the image and fill up an empty corner with elements that reinforce the idea of a medieval battle.

Fig. 4.21: Within the organization of a properly structured composition, such a story moment still require a sense of chaos. This was achieved by constantly changing the angles of both weapons and flags.

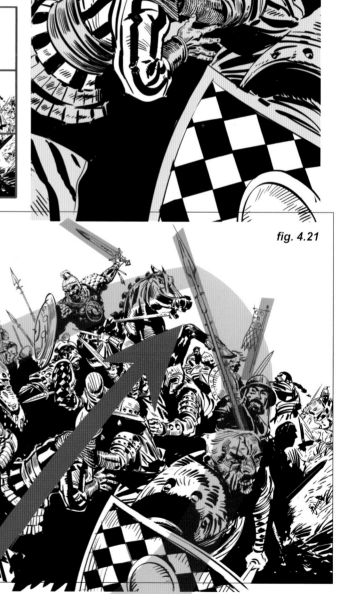

fig. 4.20

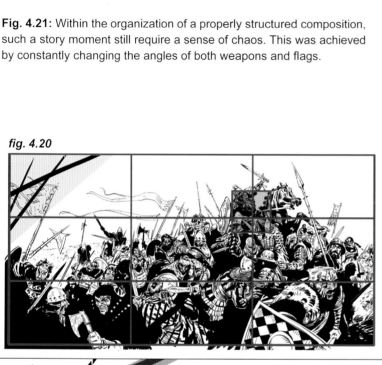

fig. 4.21

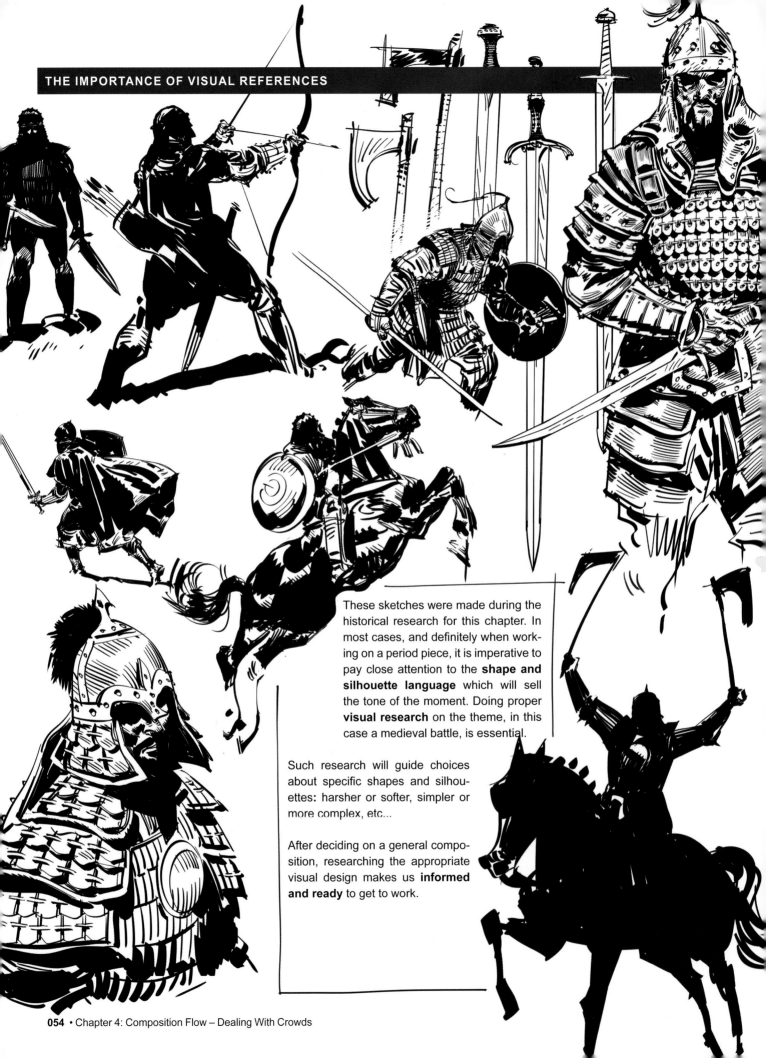

These sketches were made during the historical research for this chapter. In most cases, and definitely when working on a period piece, it is imperative to pay close attention to the **shape and silhouette language** which will sell the tone of the moment. Doing proper **visual research** on the theme, in this case a medieval battle, is essential.

Such research will guide choices about specific shapes and silhouettes: harsher or softer, simpler or more complex, etc...

After deciding on a general composition, researching the appropriate visual design makes us **informed and ready** to get to work.

THE SUBTLE STEP BETWEEN 1·85:1 AND 2·35:1

The soccer match on page 046 (fig. 4.7) showed an example of adjusting between 1.85:1 and 2.35:1 frames. Let's dive a bit deeper into working with these subtly different aspect ratios.

Usually a change in aspect ratio implies a rethinking of the composition, some reorganizing of the elements in the shot, maybe changing the camera position, and even adjusting the overall philosophy of what to show and how. However, **switching from 1.85 to 2.35 or vice versa will, for the most part, imply only a slight reframing of the shot.**

There are essentially **three ways** to do it:

- **keep the width** of the frame and adjust only the height
- **keep the height** of the frame and adjust only the width
- **find a compromise between the two**

Let's look at the first two cases for now.

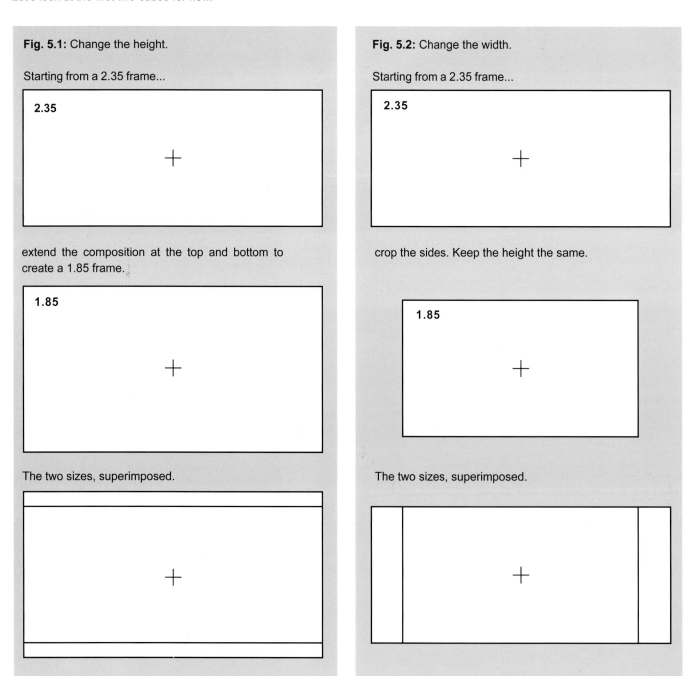

Fig. 5.1: Change the height.

Starting from a 2.35 frame...

2.35

extend the composition at the top and bottom to create a 1.85 frame.

1.85

The two sizes, superimposed.

Fig. 5.2: Change the width.

Starting from a 2.35 frame...

2.35

crop the sides. Keep the height the same.

1.85

The two sizes, superimposed.

Before "translating" a scene from one format to the other, the first thing to ask is **what information in it is most valuable?** What part of the original frame (whether 1.85 or 2.35) adds the best visual information to the scene? Is it near the top and bottom, or at the sides? Then, based on that, decide on which dimension to modify in order to preserve the integrity of the story. Let's explore a few practical examples.

CHANGING THE WIDTH / KEEPING THE SAME HEIGHT

The essential elements of this illustration are three pirates in a rowboat moving from one galleon to another on high seas.

Fig. 5.3: The 2.35:1 format includes all the essentials without showing too much galleon and sky at the top, or too much ocean at the bottom, neither of which would actually add to the narrative moment, so the 2.35:1 aspect ratio seems perfect. But what if we have to use a 1.85:1 aspect ratio?

Fig. 5.5: Since adding more to the top or bottom would not enhance the story, this 1.85:1 frame keeps the same height while cropping the sides. But it is not a pure center extraction, which would crop the left and right sides equally. The original composition had "more air" on the right, allowing us to crop more from that side, but not so much as to remove the distant galleon completely; some of it needs to be visible as the pirates' destination. Finally, cropping just a bit from the left eliminates a part of the foreground galleon that is not crucial to the story.

Fig. 5.4: This thumbnail shows how the foreground galleon is an overwhelming mass that creates dramatic visual pressure on the small boat of pirates.

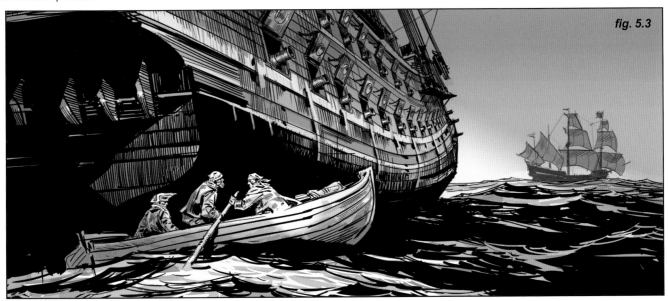

fig. 5.3

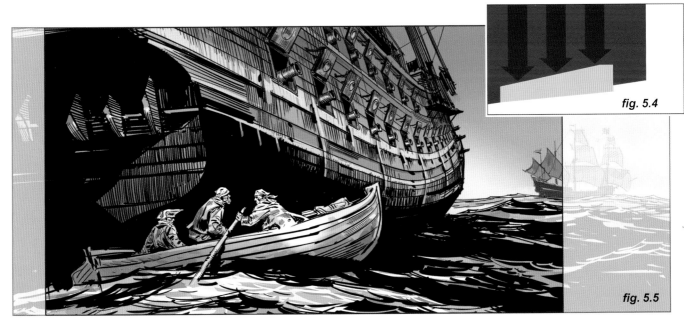

fig. 5.4

fig. 5.5

Let's check out the framing possibilities for a group of Marines running uphill to attack a heavily defended fortification, with some Navy planes providing cover. Again, the frames' height is consistent on both 2.35:1 and 1.85:1, adjusting only the width. Another element that is constant between these two compositions is that the bunker remains pretty much up against the right side of the frame, **cornered in that point of pressure** (see fig. 5.7, yellow arrow), beyond the rule of thirds. This enhances the level of tension between the two main elements in the shot, having the attackers' objective really pressed up against the edge (see fig 1.8, page 014).

Fig. 5.6: This thumbnail shows the basic dynamics of the shot and how it creates a sense of organized depth: elements decrease in size as they get further away from the lens.

Fig. 5.7: The central Marine exemplifies the essentials of the shot (Marine attack, uphill target). Everything else around him basically echoes his action and therefore potentially requires less detail (see *Framed Ink*, page 048).

fig. 5.7 *fig. 5.6*

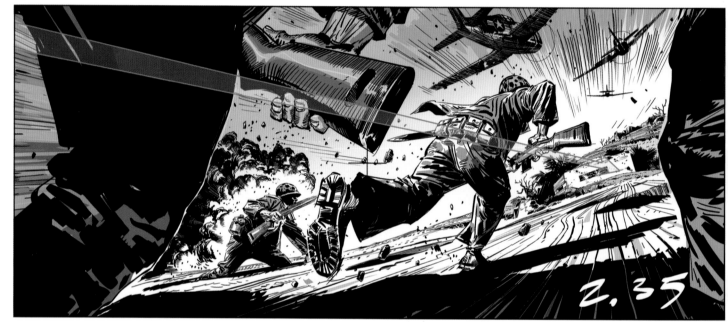

Fig. 5.8: This 1.85 version still shows part of the foreground Marines (left and right) as framing devices. The visuals that were cropped out are the ones that added less narrative information to the shot. Still, the action is explained clearly and the off-balance, pressure-release dynamics of the composition are left pretty much untouched.

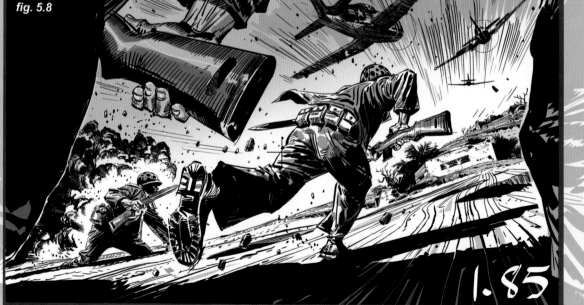

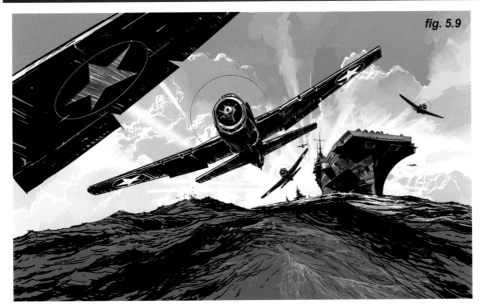

fig. 5.9

Fig. 5.9: Starting with this full, original shot, let's come up with ways to crop compelling 2.35:1 and 1.85:1 compositions from it.

fig. 5.10

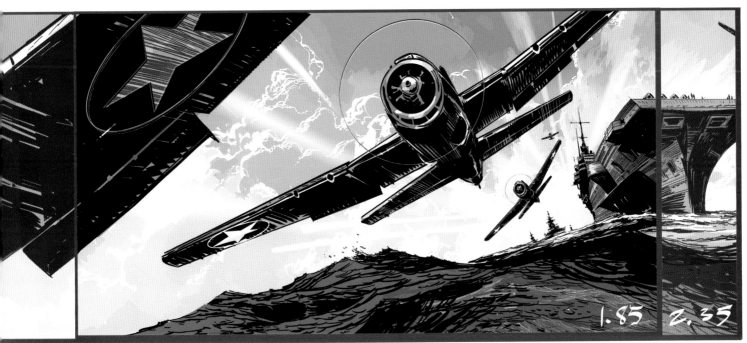

fig. 5.11

Fig. 5.10: To enhance the dynamics of the shot, the planes were lined up following the principle of big, medium and small, (see *Framed Ink*, page 049), and in a perspective where the vanishing point lands right on the most distant carrier (circled in red).

Fig. 5.11: First of all, the camera has been tilted to the right in order to emphasize the diagonal created by the ocean's surface. As the camera rotates clockwise, the ocean's surface will appear to be inclining more and more in the opposite direction.

In this instance, to maintain the integrity of the shot's narrative, the center of the composition remains the same for both the 1.85 and 2.35 frames. Both the left and right sides were cropped equally, as opposed to the previous examples in which one side was cropped more than the other.

Here, cropping more from the right would put the central airplane's wing too close to the edge of the frame, creating an uncomfortable tangent. And cropping more from the left would take away too much of the visual interest and detail of the foreground plane's wing. Therefore, keeping the compositions centered was the best solution.

Meanwhile, back in the Pacific...

Fig. 5.12: This is the same illustration as fig. 5.3. Its format is 2.35:1. Now let's look at how to adapt it to 1.85:1 by keeping the same width and adjusting the height.

Fig. 5.13: In this case the composition was extended mostly at the top. The visual information available in that part of the scene offered more character and a better understanding of the imposing size and nature of the vessel up against the small rowboat and its occupants, enhancing the sense of drama. Still, some ocean was added at the bottom to balance out the composition better.

fig. 5.12

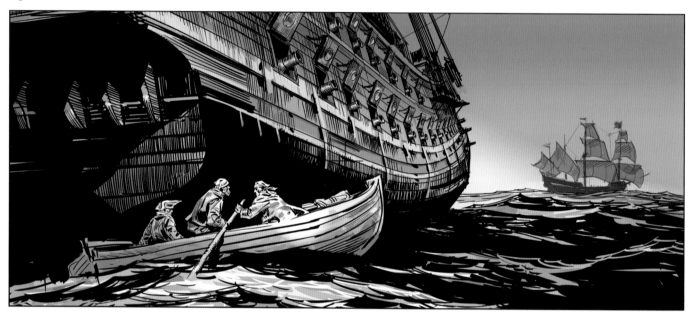

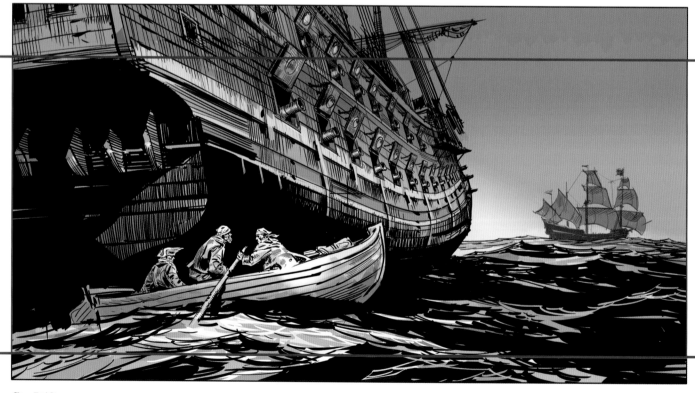

fig. 5.13

- Area in red blocks pirate ship.
- Area in purple blocks row boat
- Yellow line represents the horizon

fig. 5.14

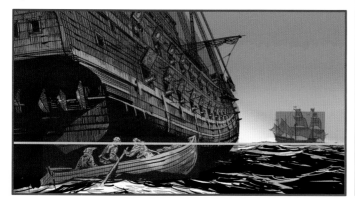

fig. 5.15

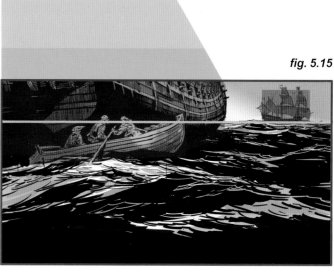

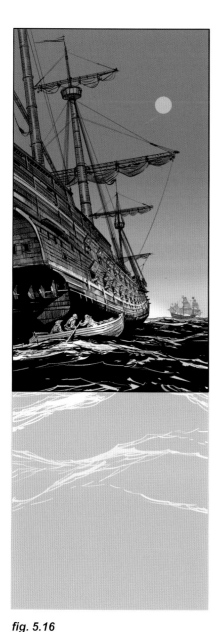

fig. 5.16

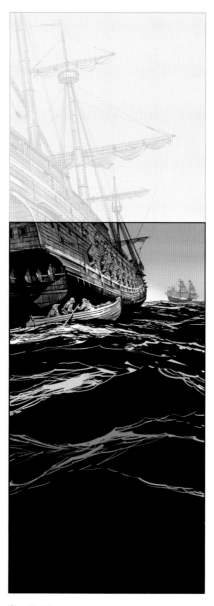

fig. 5.17

But what if we need a different feel for the moment? A bit more unusual? A bit more extreme?

Fig. 5.14: Rather than looking for balance, here all real estate was added to the top to show even more of the galleon than in fig. 5.13. This works if the **vessel's scale** was primary to the story moment.

Fig. 5.15: This shot adds a lot more of the ocean at the bottom of the frame. Now the first element we measure the tiny rowboat against is this immense body of water, which emphasizes the precariousness of its three occupants' situation. The threat now is nature, as opposed to the ship and whatever might come from it.

Figs. 5.16 and 5.17: When the scene is represented in a vertical format, sliding the frame up or down makes an even bigger difference to the tone and narrative intention of the shot. Now, as the adventure unfolds, either the scale of the galleon in the night (fig. 5.16) or the immensity of the ocean (fig. 5.17) becomes truly overwhelming.

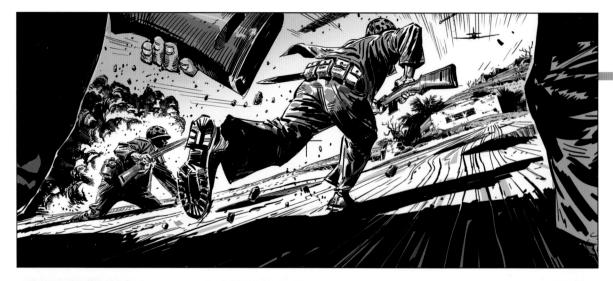

fig. 5.18

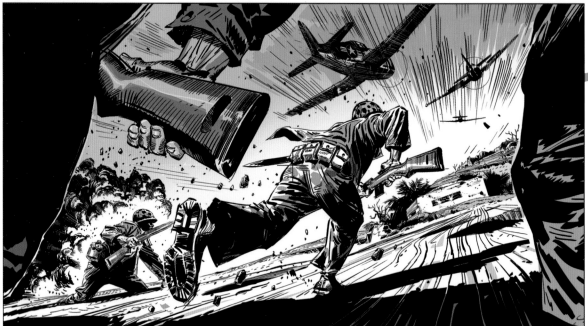

fig. 5.19

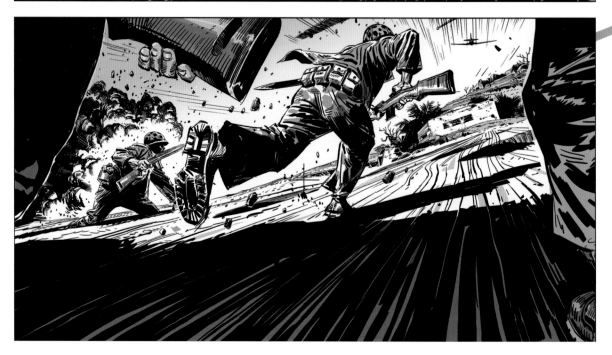

fig. 5.20

fig. 5.21

fig. 5.22

fig. 5.23

Fig. 5.18: This 2.35 frame focuses on the main, **central Marine** who establishes the action, the bunker pressed up against the corner, and **character shapes** on both sides that frame all this.

Fig. 5.19: This 1.85 frame crops a bit from the bottom and extends the top to include the supporting airplanes. The Marines are not alone.

Fig. 5.20: Sliding the 1.85 frame down changes the tone of the scene by eliminating most of the airplanes. Now it's only about the men on the ground and the difficulty of advancing on such terrain.

Figs. 5.21, 5.22, and 5.23: These thumbnails synthesize the three compositions on the previous page.

Figs. 5.24 and 5.25: The frame was pushed even further down to see more of the ground while still keeping the bunker in the shot. This is a way to tell the story from the point of view of one of the assaulting Marines, trying to keep his head down while bullets whiz past, the boots of his brothers-in-arms randomly coming in and out of the shot (the frame was widened to include more of the other soldiers' legs in the shot), while rocks and dust are being kicked up.

fig. 5.24

fig. 5.25

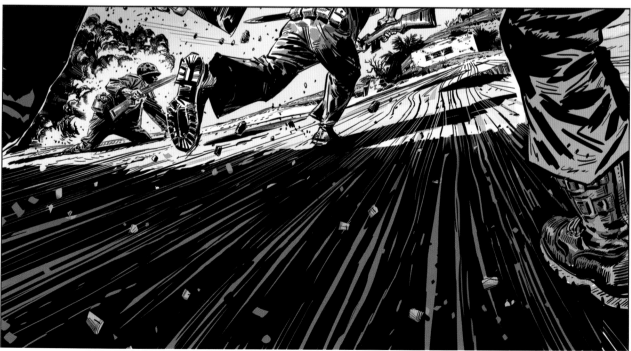

When converting from one format to another (1.85 to 2.35, or vice versa) Sometimes it pays to **average out** or compromise between their height and width.

Fig. 5.26: Start by superimposing both formats so that they become a single camera guide. Then identify the point where the energy **emanates from** or **converges to.** In this case, it is the vanishing point of the line of flying planes (point **1** at the orange cross). Working on all the variations by starting with this point will ensure the compositions keep a consistent sense of dynamics.

Fig. 5.27: Draw lines from point **1** to the corners of either the 1.85 or the 2.35 frame (your choice) and then beyond. **This exercise uses 1.85.** Then choose the exact spots along the (green) lines to place the 1.85 corners (**A, B, C, D**) of a new, enlarged (purple) combined frame. Note that the enlarged (purple) version of the 2.35:1 frame still falls short of reaching the top and bottom edges of the smaller 1.85:1 (red) frame, while both sides of the 2.35 actually expand wider than the ones of 1.85.

Fig. 5.28: This compares the original 1.85 format (red) and the enlarged 2.35 format (purple) using a consistent point to convert between both aspect ratios.

Fig. 5.29: The final image for both the 1.85 (red) and the 2.35 (purple) framing versions.

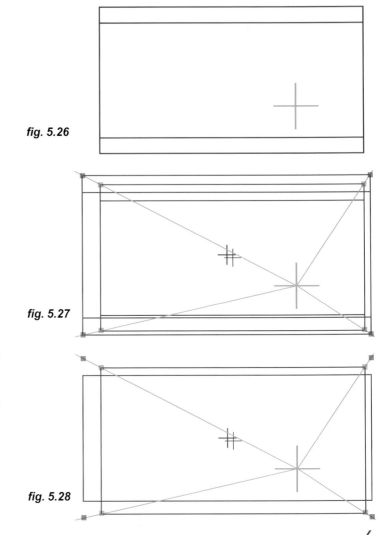

fig. 5.26

fig. 5.27

fig. 5.28

fig. 5.29

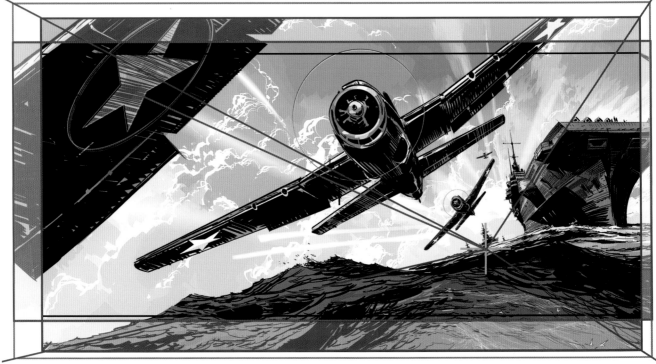

6

AGAINST THE GRAIN

(COMPOSING AGAINST THE FORMAT)

Sometimes we will work with a horizontal frame but need to show verticality, or will work with a vertical aspect ratio when the scene really calls for a horizontal display of the elements. Despite these limitations there are still a number of options to maximize the elements and parameters we have been given. Here are some examples:

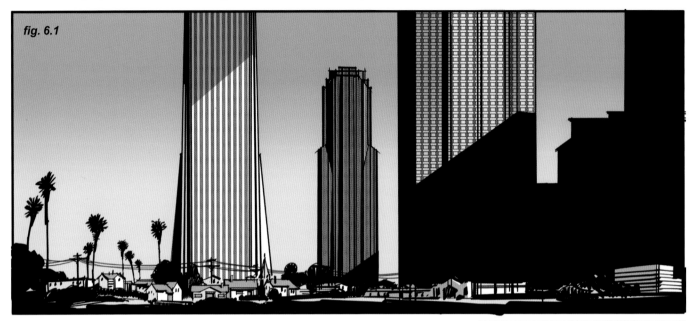

fig. 6.1

Fig. 6.1: Height by contrast. This shot plays up the massive verticality of the skyscrapers against the tiny shapes and overall volume of the houses and palm trees at the bottom. The tall buildings play out like the legs of massive giants.

Fig. 6.2: The heavy forces of these big buildings put downward pressure on the suburb at their feet, visually spreading it thin, horizontally, at the very bottom of the scene.

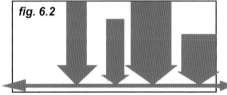

fig. 6.2

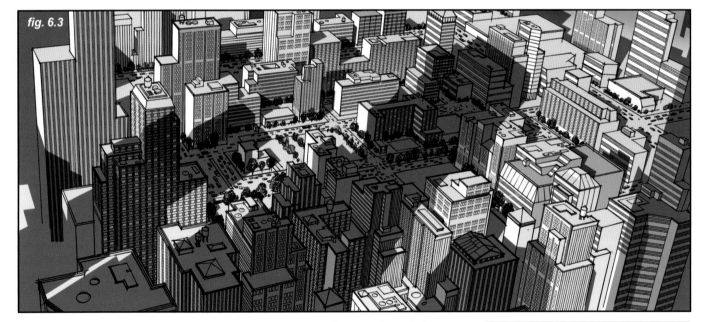

fig. 6.3

Fig. 6.3: Height by proxy. Projecting the shadow of a very tall subject onto much smaller ones will, without needing to see its actual body, imply a strong sense of size or scale by showing the existing disproportion.

Fig. 6.4: A simplified version of this shot's mechanics.

fig. 6.4

fig. 6.5

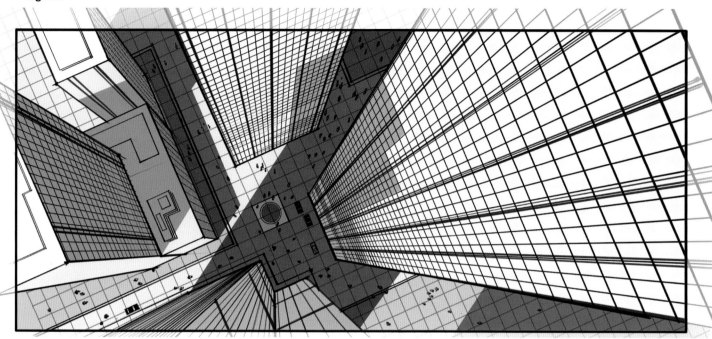

Fig. 6.5: Extreme down shot. The next best thing to a sense of verticality is a strong sense of depth. The extreme perspective of a full down shot implies the great height of these buildings, the subject of the shot.

Fig. 6.6: Essence of the dynamics displayed in fig. 6.5.

fig. 6.6

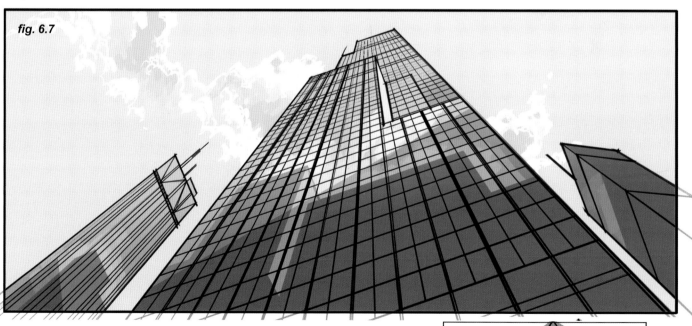

fig. 6.7

Figs. 6.7 and 6.8: Extreme upshot. The same philosophy applies to the reverse angle of an upshot.

fig. 6.8

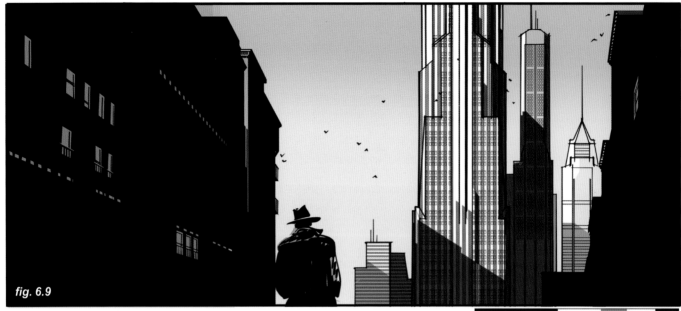

fig. 6.9

Fig. 6.9: Visually "cropping" the sides with solid, darker shapes creates the illusion that the frame is narrower than it actually is, so that the positive space in between seems to have a more vertical aspect ratio.

Fig. 6.10: A simplified version of the shot's mechanics.

fig. 6.10

A FEW WORDS ON CHEATING PERSPECTIVE

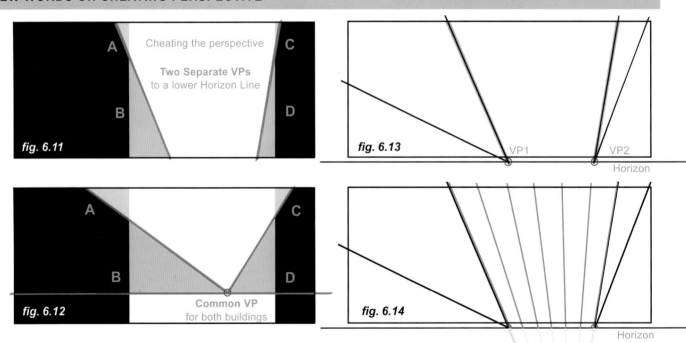

Fig. 6.11: It works best if the silhouetted buildings at the left and right of frame feel as close as possible to purely vertical sides of an actual frame (**A–B, C–D**). Because the buildings are parallel, their rooflines have a common vanishing point, as shown in fig 6.12. But these inclined shapes of the rooftops are too angular to work as a straightforward frame for this composition and would get too much attention (blue areas).

Fig. 6.12: To make the silhouettes feel more vertical, **the perspective was cheated** by having the roofs **go to two different vanishing points** (one per building, as opposed to both going to the same VP as parallels do). This **feels less angular** and more like a long-lens style.

Fig. 6.13: To make the silhouettes feel more vertical, the perspective was cheated by having the roofs go to two different

vanishing points (one per building, as opposed to both going to the same VP as parallels do). This feels less angular and more like a long-lens style. This brings the rooftop lines (orange) closer to vertical.

Fig. 6.14: If we ever needed additional lines between the edges of both roofs, we would add a third vanishing point (blue).

fig. 6.16

In the reverse case, try to emphasize the horizontal theme in as many ways possible.

Figs. 6.15 and 6.16: In this train station illustration, the whole frame is about horizontals to the point that it is impossible to escape the notion, especially since (with the exception of the very distant antenna) no verticals are present in the whole scene, including an otherwise clear and uninterrupted horizon line.

If this scene were to be filmed on a movie set, rather than a designed drawing, the camera would have to be placed so that its specific point of view excludes any verticals that exist in the area. As usual, composing is not only about how we play with the elements within the frame, but also what we purposefully and selectively leave out of it.

fig. 6.15

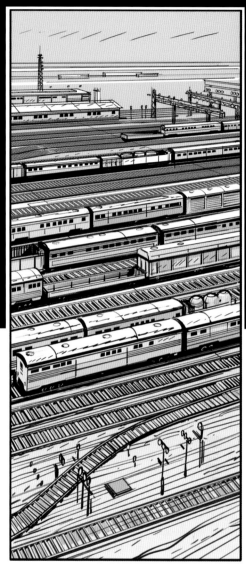

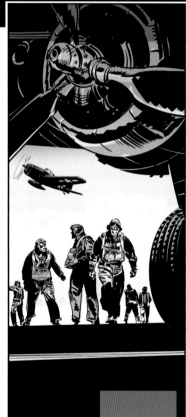

fig. 6.17

fig. 6.18

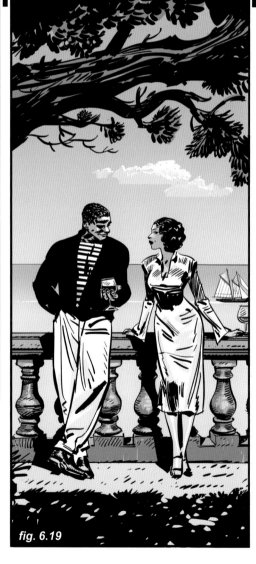

fig. 6.19

Fig. 6.17: Creating a secondary frame within the main one is another way to modify the perception of a scene. Here the wing of this WWII plane at the top, its landing gear to the right, and the ground below reduces the field of action to a smaller, square area (as opposed to vertical).

Fig. 6.18: This thumbnail shows the dynamics of fig. 6.17.

Fig. 6.19: Here, visual devices such as the tree at the top and its shadow at the bottom, plus the cloud, stone railing and the wake of a sailing ship, help reframe and also visually stretch the horizontal perception of the shot, and minimize the verticality of its 2.35 frame.

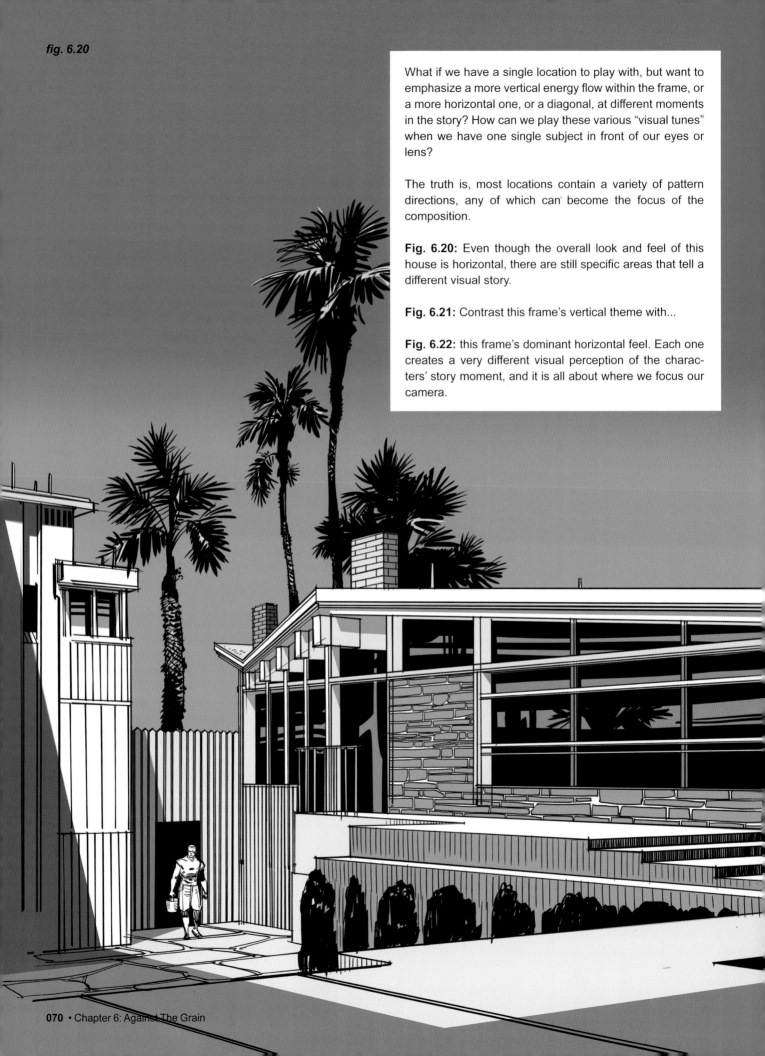

fig. 6.20

What if we have a single location to play with, but want to emphasize a more vertical energy flow within the frame, or a more horizontal one, or a diagonal, at different moments in the story? How can we play these various "visual tunes" when we have one single subject in front of our eyes or lens?

The truth is, most locations contain a variety of pattern directions, any of which can' become the focus of the composition.

Fig. 6.20: Even though the overall look and feel of this house is horizontal, there are still specific areas that tell a different visual story.

Fig. 6.21: Contrast this frame's vertical theme with...

Fig. 6.22: this frame's dominant horizontal feel. Each one creates a very different visual perception of the characters' story moment, and it is all about where we focus our camera.

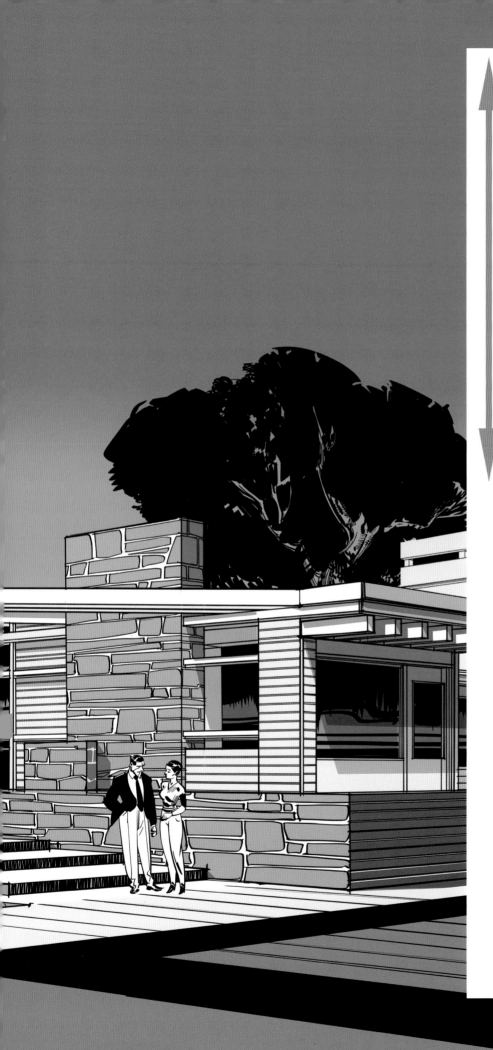

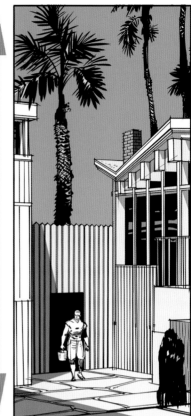

fig. 6.21

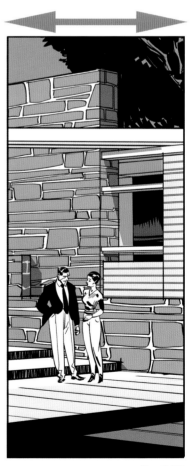

fig. 6.22

7

SPLITTING THE SCREEN

— COMPOSING BY THIRDS, HALVES AND FOURTHS —

Much of the discussion so far has related to the flow of energy through the frame, flow that itself tells a story with its ups and downs, pushes and pulls, and points of inflection (turning points). This **organic approach** plays with lines of tension between elements, and sometimes those elements focus attention by pointing in certain directions. All this applies to any aspect ratio.

Now let's investigate a **more rational and methodical sense of structure.**

Splitting a panel into equal parts, both vertically and horizontally, can create very interesting balanced rhythms and provide a good basis or starting point for the work. These partitions can be used in various ways.

Fig. 7.1: Focus on one or more **intersections** of the dividing lines (dots).

Figs. 7.2 and 7.3: Exploit the **length** of one (or more) of any of the dividing lines.

Figs. 7.4 and 7.5: Use one or several of the zones found within the dividing lines...

...or pretty much **any combination** thereof.

When a frame (of any aspect ratio) is **divided by thirds,** it can bring a sense of composition that, while not the self-conscious option of a perfectly symmetrical, or a more extreme composition by fourths, still retains a sense of balance that is clear and comfortable to the eye.

The following pages show examples of all this, analyzed in both a 2.35:1 format (horizontal and vertical) plus a square version of the following scenes:

- A **medieval queen** delivering a harangue to her warriors.

- Two characters gazing into the distance from the **top of a cliff.**

- **Two sailors on a small boat,** surreptitiously approaching a galleon in the middle of the night.

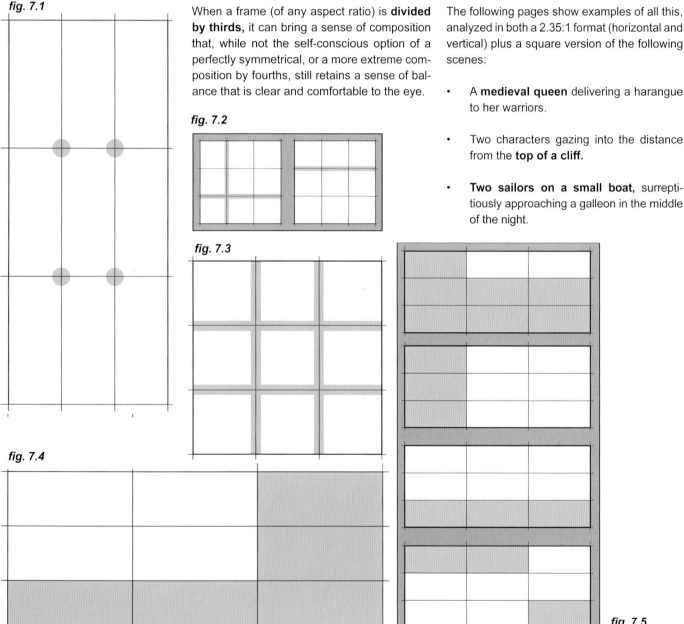

fig. 7.1

fig. 7.2

fig. 7.3

fig. 7.4

fig. 7.5

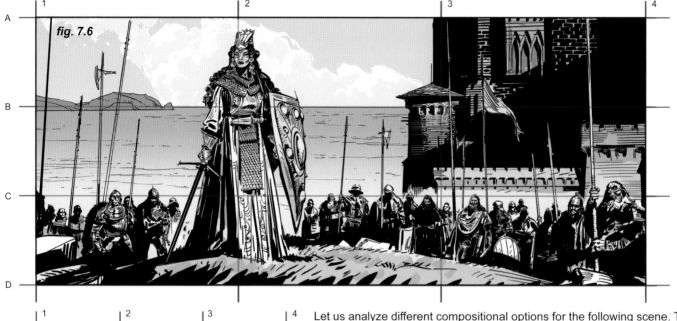

fig. 7.6

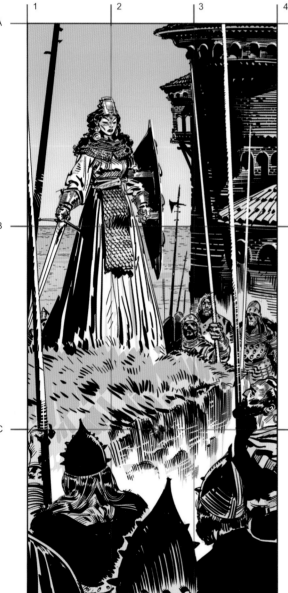

Let us analyze different compositional options for the following scene. The main narrative points (or areas) of these frames coincide with partition lines (verticals **1, 2, 3, 4**; and horizontals **A, B, C, D**).

Fig. 7.6: The queen is positioned along vertical **2**, while the castle is located between **3** and **4**. The ocean's horizon line is along **B,** and the overall line defined by the heads of the warriors behind the queen adheres to line **C.**

Figs. 7.7 and 7.8: The queen, the castle and the horizon are positioned along the same lines as in fig. 7.6, but the soldiers have moved to the foreground, along line **C.** The sideways compression of these frames dramatically reduces the space between the queen and her castle, and no longer allows much room for the crowd to be clearly positioned between the two.

Notice that having the castle's side along line **3** does not mean smaller details of the building cannot protrude or go a little past that line. But certainly the main block of the fortress stands between lines **3–4.**

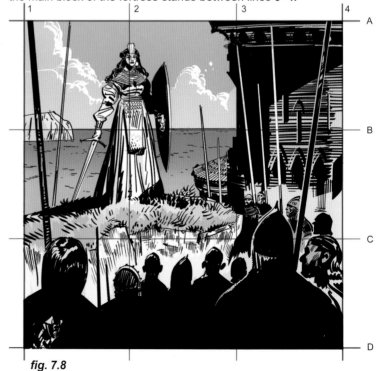

fig. 7.7

fig. 7.8

The dramatic dynamics that are available with an elongated frame, whether vertical or horizontal, are often much more difficult to achieve in a purely square 1:1 aspect ratio.

If our intention for this medieval shot is to focus on the **grand space** of the general location, a horizontal frame (fig. 7.6) allows us to show off the long horizon line and the vast number of soldiers gathered for the moment. A vertical format (fig. 7.7) is conducive to better representing a sense of **hierarchy,** with the queen well above the crowd. A square format (fig. 7.8) might look less elegant for a shot like this, but it could be an opportunity to highlight the **roughness** of the times and the lives of these characters.

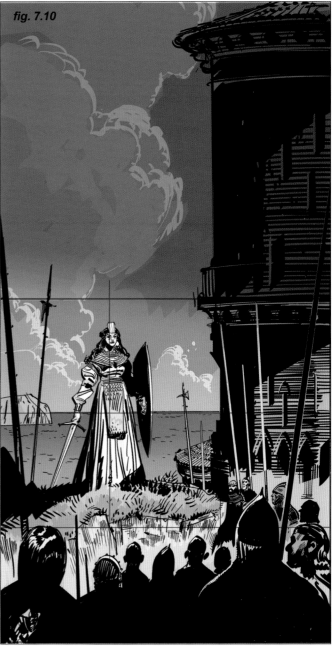

fig. 7.10

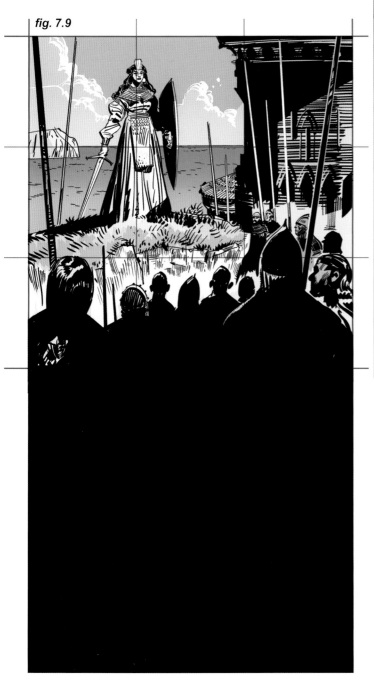

fig. 7.9

Figs. 7.9 and 7.10: These are an exercise in recuperating some of the elegance of the wider and taller shots, **using the exact same composition as the square shot,** but adding some real estate at the bottom or the top.

Fig. 7.9 is more grounded, extending the lower part and using the additional area to include more of the warriors' bodies, which visually compress the area where the queen is, making it potentially more about her **moment of responsibility** to her followers, while the warriors have a bigger weight in this particular moment.

Fig. 7.10 on the other hand is about the queen and the grand space around her, with an overall feel of **transcendence,** giving her an aura of a true leader who will take them all to victory!

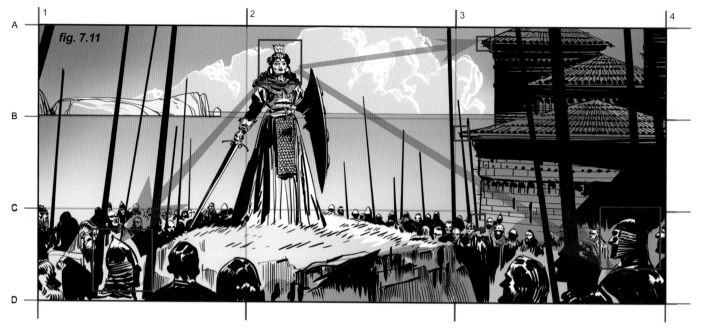

fig. 7.11

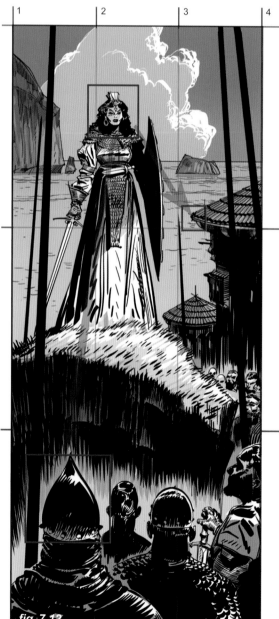

fig. 7.12

Let's continue to compare shots of the queen and her warriors, and instead explore how they follow the **dynamics of pressure vs. release, push vs. pull, and turning points.**

Figs. 7.11 and 7.12: Both the queen and the background fortress have been **pushed slightly to the right of verticals 2 and 3.** Positioning her head in a more central point **creates, relative to other key points in the panel** (prominent soldiers/castle corners, in red), **lines that imply tension and drama** (red arrows) by pulling in directions that, **opposed to what perfect horizontals and verticals would do,** create more unbalanced and dynamic diagonals.

Fig. 7.13: This composition is fully flat and symmetrical to emphasize the solemnity of the moment, abandoning anything to do with a division by thirds.

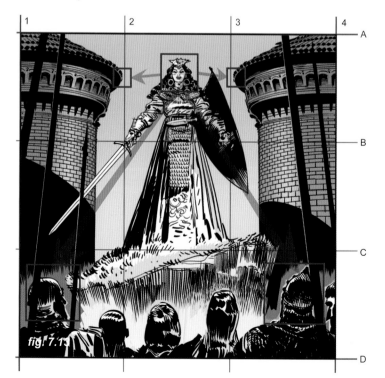

fig. 7.13

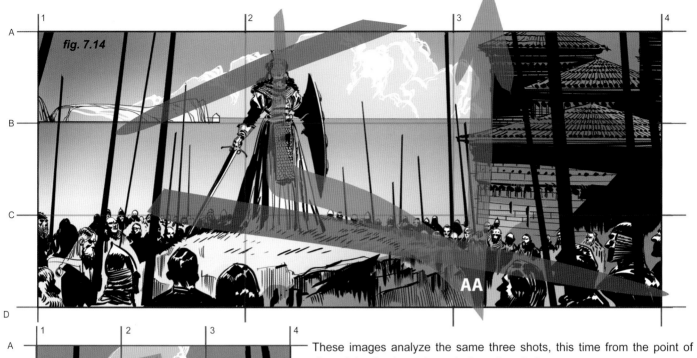

fig. 7.14

These images analyze the same three shots, this time from the point of view of the dominant dynamic lines (in color).

Figs. 7.14 and 7.15: In both cases the energy starts off at the queen's head position and shoots straight down vertically (orange line), then swerves to the right, pulling the dynamics down diagonally to a sudden stop (point **AA**) where it redirects straight upward **with a bang.**

Fig. 7.16: With the queen centered, the energy flows downward (orange line), swerves right and then suddenly turns around (point **BB**) describing a light diagonal to the left. In all cases, these **dynamic backbones** (orange lines) show visible flows and turns that create visual drama in our compositions.

The **purple lines** indicate secondary dynamics within the frames. In fig. 7.14 they emphasize a sense of depth and perspective by a proper use of elements such as the clouds in the background and the rock's surface in the foreground.

In fig. 7.15 the secondary dynamics flow through the heads of all the characters in the shot, while in fig. 7.16 the direction of the queen's arms creates a solemn effect.

fig. 7.15

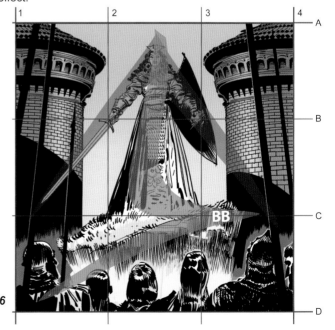

fig. 7.16

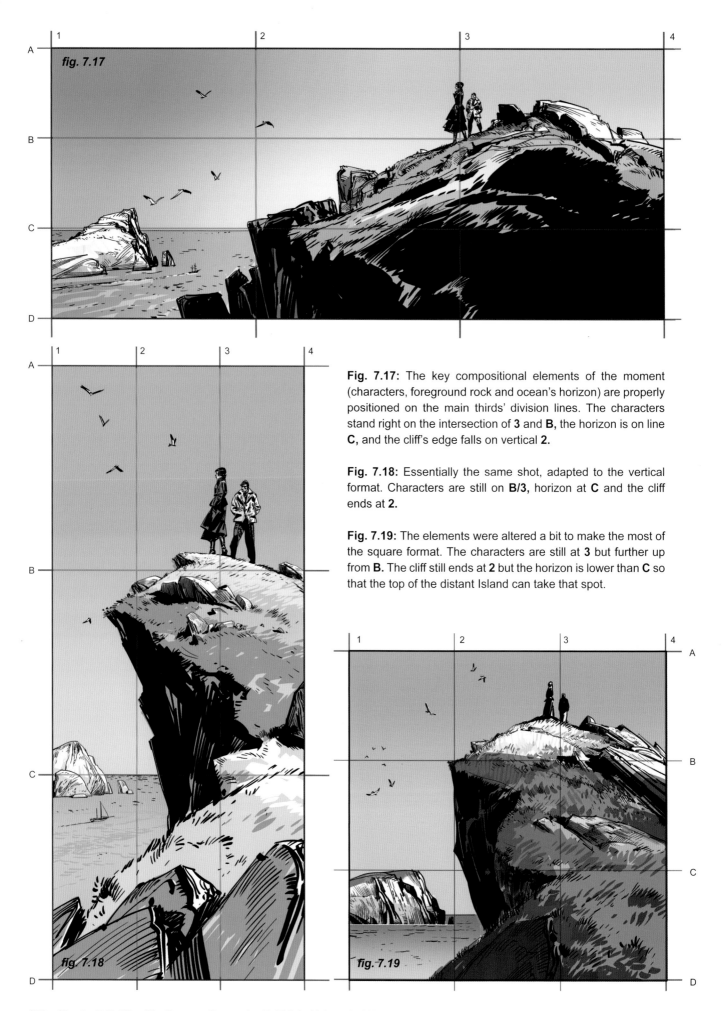

Fig. 7.17: The key compositional elements of the moment (characters, foreground rock and ocean's horizon) are properly positioned on the main thirds' division lines. The characters stand right on the intersection of **3** and **B**, the horizon is on line **C**, and the cliff's edge falls on vertical **2**.

Fig. 7.18: Essentially the same shot, adapted to the vertical format. Characters are still on **B/3**, horizon at **C** and the cliff ends at **2**.

Fig. 7.19: The elements were altered a bit to make the most of the square format. The characters are still at **3** but further up from **B**. The cliff still ends at **2** but the horizon is lower than **C** so that the top of the distant Island can take that spot.

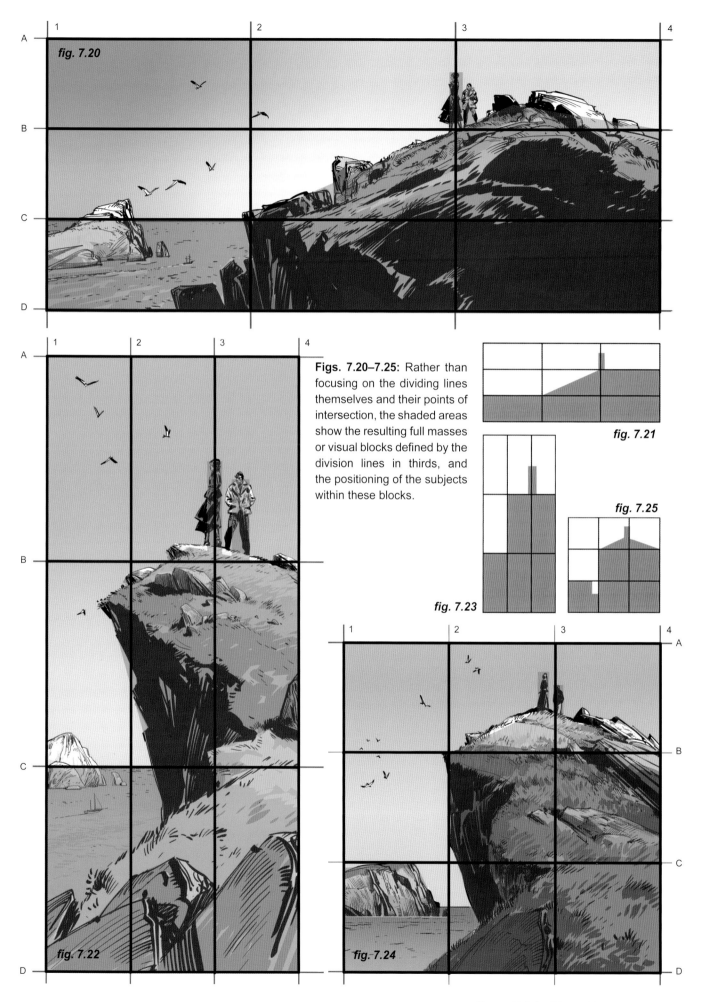

Figs. 7.20–7.25: Rather than focusing on the dividing lines themselves and their points of intersection, the shaded areas show the resulting full masses or visual blocks defined by the division lines in thirds, and the positioning of the subjects within these blocks.

fig. 7.20

fig. 7.21

fig. 7.22

fig. 7.23

fig. 7.24

fig. 7.25

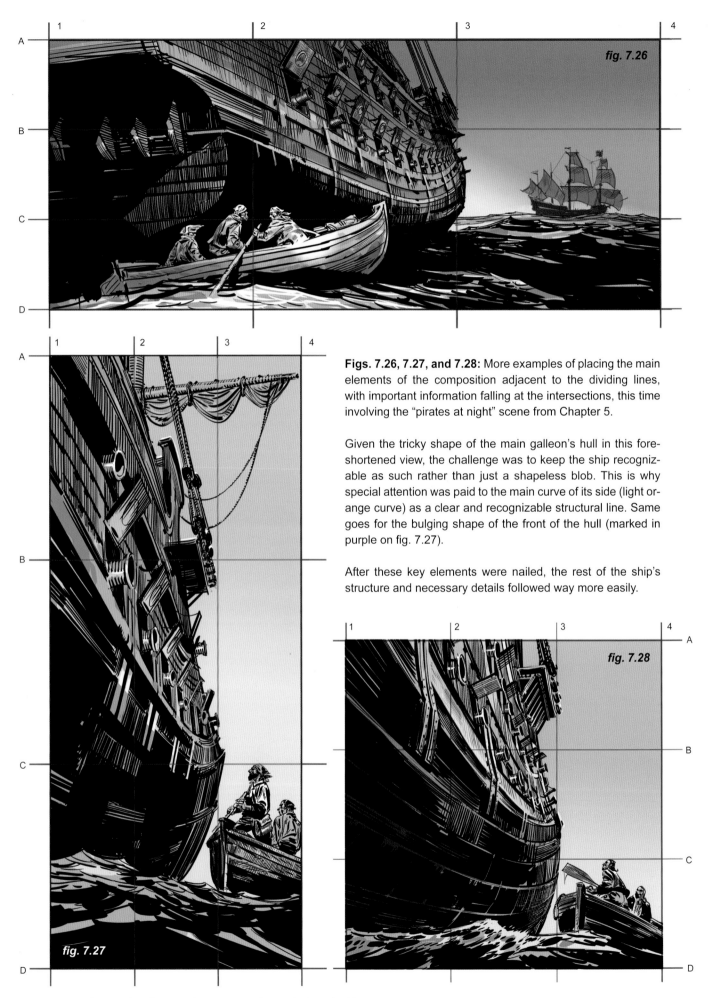

Figs. 7.26, 7.27, and 7.28: More examples of placing the main elements of the composition adjacent to the dividing lines, with important information falling at the intersections, this time involving the "pirates at night" scene from Chapter 5.

Given the tricky shape of the main galleon's hull in this foreshortened view, the challenge was to keep the ship recognizable as such rather than just a shapeless blob. This is why special attention was paid to the main curve of its side (light orange curve) as a clear and recognizable structural line. Same goes for the bulging shape of the front of the hull (marked in purple on fig. 7.27).

After these key elements were nailed, the rest of the ship's structure and necessary details followed way more easily.

fig. 7.26

fig. 7.27

fig. 7.28

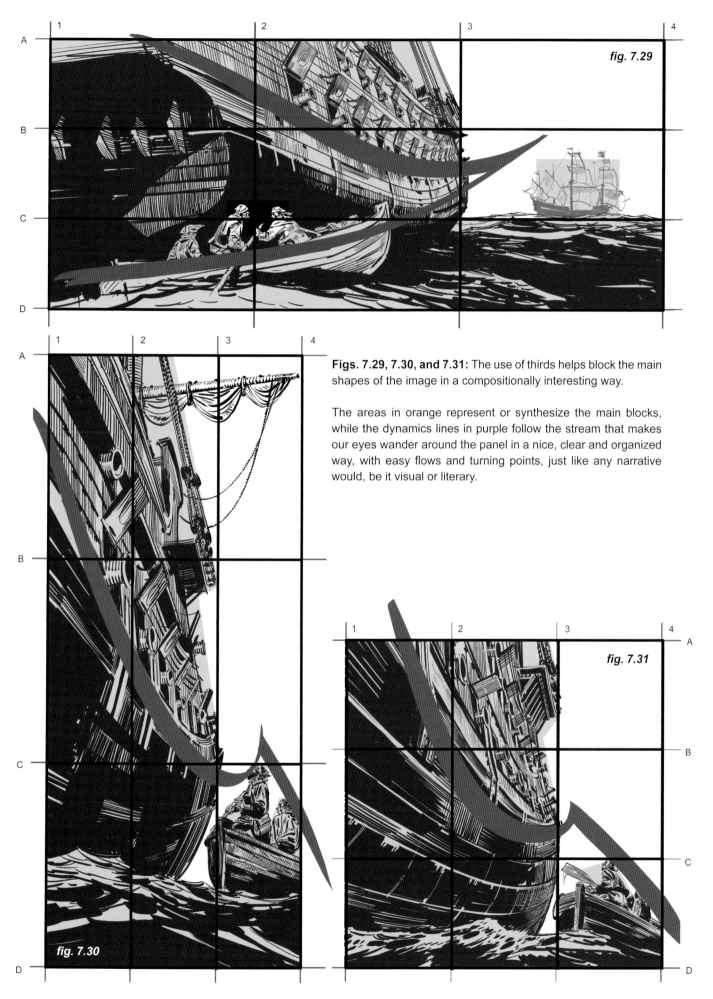

Figs. 7.29, 7.30, and 7.31: The use of thirds helps block the main shapes of the image in a compositionally interesting way.

The areas in orange represent or synthesize the main blocks, while the dynamics lines in purple follow the stream that makes our eyes wander around the panel in a nice, clear and organized way, with easy flows and turning points, just like any narrative would, be it visual or literary.

fig. 7.29

fig. 7.30

fig. 7.31

SHOTS WITH A PERSONALITY

When it comes to organizing visuals via a structured division of the panels, the rule of thirds is not the only way to go. Dividing the panel into halves (horizontally and vertically) is more unusual and therefore one of the more visually striking choices. Normally this approach comes across as very self-conscious and somehow mechanical, so my recommendation is to use this weird quality as a special, distinctive style for a specific sequence within the narrative.

Switching to a new visual device for a segment within a story can make the moment more memorable. It could work for a flashback, a moment, or experience the character goes through that might be significantly uncomfortable or somehow special. Here are a few examples of frames divided in half:

Fig. 7.32: Transporting heavy artillery equipment on the muddy battlefield in the early 19th century.

Fig. 7.33: Grave decision-making on a New York balcony.

Fig. 7.34: Running into a ghost when you least expect it is certainly bound to make a great conversation starter at your next reunion.

See page 085 for thumbnail schematics related to these images.

fig. 7.32

fig. 7.33

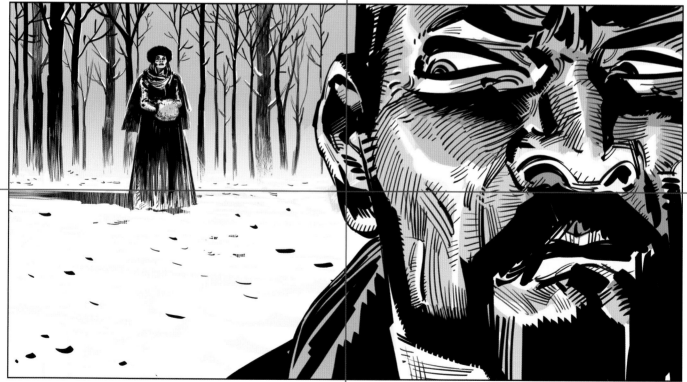

fig. 7.34

fig. 7.35

Fig. 7.35: A surreal composition for a surreal shot.

As much as possible, we try to make the elements of a scene play together toward a common goal. Sometimes the sturdiness of a 1:1 format is the right fit for an out-of-the-ordinary scene.

The mysterious and cryptic atmosphere of a night scene inside a house that might as well be a museum given the special items in it, can benefit from a frame format like this, broken up into four quadrants.

Everything in this image makes us question what is going on...and therefore wonder, what will happen next?

fig. 7.36

fig. 7.37

fig. 7.38

fig. 7.39

These four schematics represent the essential compositions for all the artwork of the previous three pages.

Fig. 7.36: The French artillery

Fig. 7.37: New York balcony

Fig. 7.38: Ghost in the woods

Fig. 7.39: Museum mystery

The closer we stick to the essence of these basic shapes, the stronger the visual statement, and the more successful the shot will be.

Dividing a frame into equal areas allows us to play within a well-structured system, which is reflected in the final image. Dividing a panel's surface beyond thirds pushes the composition toward a more extreme look...which might be a good thing; it again depends on what the story moment requires.

Here are some examples of compositions where the frame was divided by fourths, vertically and horizontally.

fig. 7.40

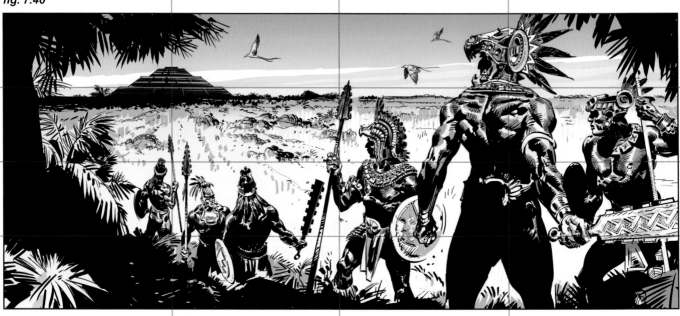

fig. 7.41

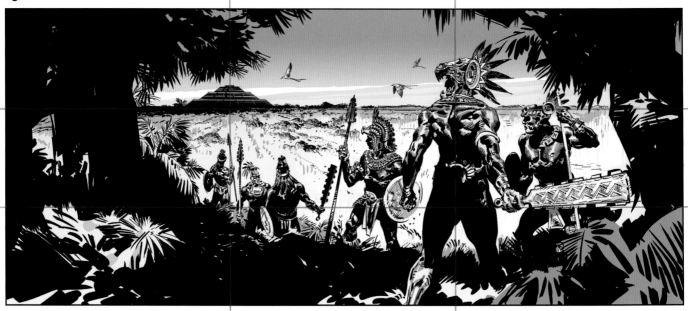

Fig. 7.40: Shows the effect of composing this group of Aztec warriors by fourths.

Fig. 7.41: For comparison's sake, this is the same illustration composed by thirds.

Fig. 7.42: These are the basic schematics for fig. 7.40. The main elements of the shot (pyramid to the left, head of the lead warrior to the right, and horizon) follow the divisions by fourths, creating a greater distance between soldier and pyramid (purple arrow) than a division by thirds would, giving it a more spacious and epic feel with **a more stretched line of tension.**

Fig. 7.43: In order to adapt the same drawing to a grid by thirds, and have the lead warrior, pyramid and the horizon follow this rule, it required a larger camera field (black frame) to include more of the surroundings than the original frame (dotted red frame).

The new composition lost the formerly epic line of tension between soldier and pyramid, and gained more of the jungle, turning it into an establishing shot that portrays more of the relationship between the group and the general environment rather than the characters themselves. Whichever shot rules the day will depend on the narrative needs for the moment.

Fig. 7.44: Basic compositional schematic for fig. 7.45.

Fig. 7.45: This Avenue shot shows how dividing by fourths can bring a sense of elegance that other partition systems may not. Notice there are no distracting elements at the center of the frame that would take away from the woman's prominence; which is further enhanced by the fact that she is staged in a pool of light, making her face more visible to the camera than any other character's face in the shot.

fig. 7.42

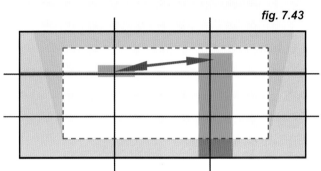

fig. 7.43

fig. 7.44

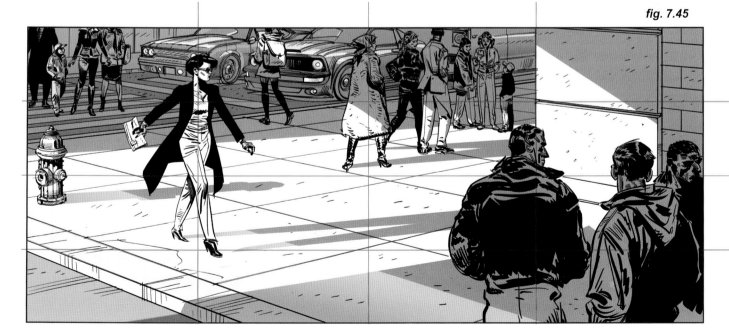

fig. 7.45

fig. 7.46

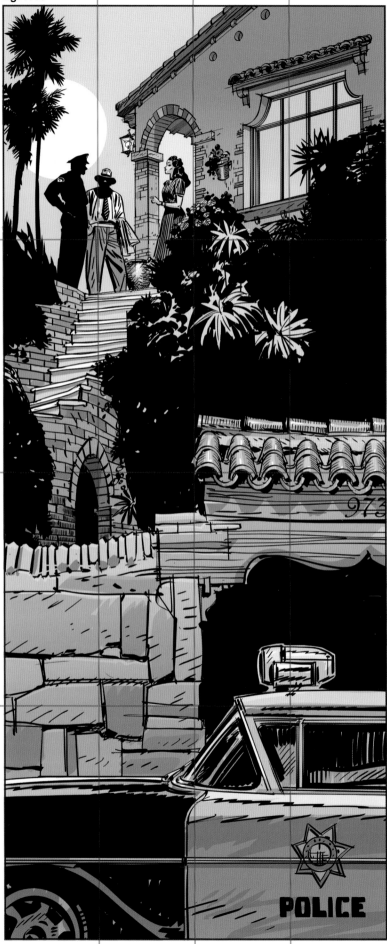

Fig. 7.46: Since the actual area that the main subject (the three characters) occupies within the frame is quite small, and there are many other elements going on in the scene, it is important to crop out anything unnecessary and keep the shot simple and clear.

Therefore, just enough information of the surrounding elements is included: a corner of the house, some of the steps that lead up to it, a barely silhouetted garden, about half of the entrance gate (bottom) at street level, and again, just enough of the vehicle to know it is a patrol car.

Fig. 7.47: This schematic shows how the car at the bottom of the steps favors screen right in order to counterbalance the top-left position of the two cops and the homeowner.

fig. 7.47

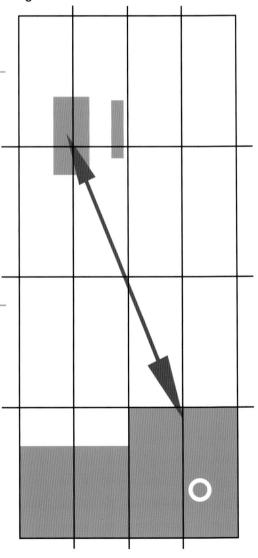

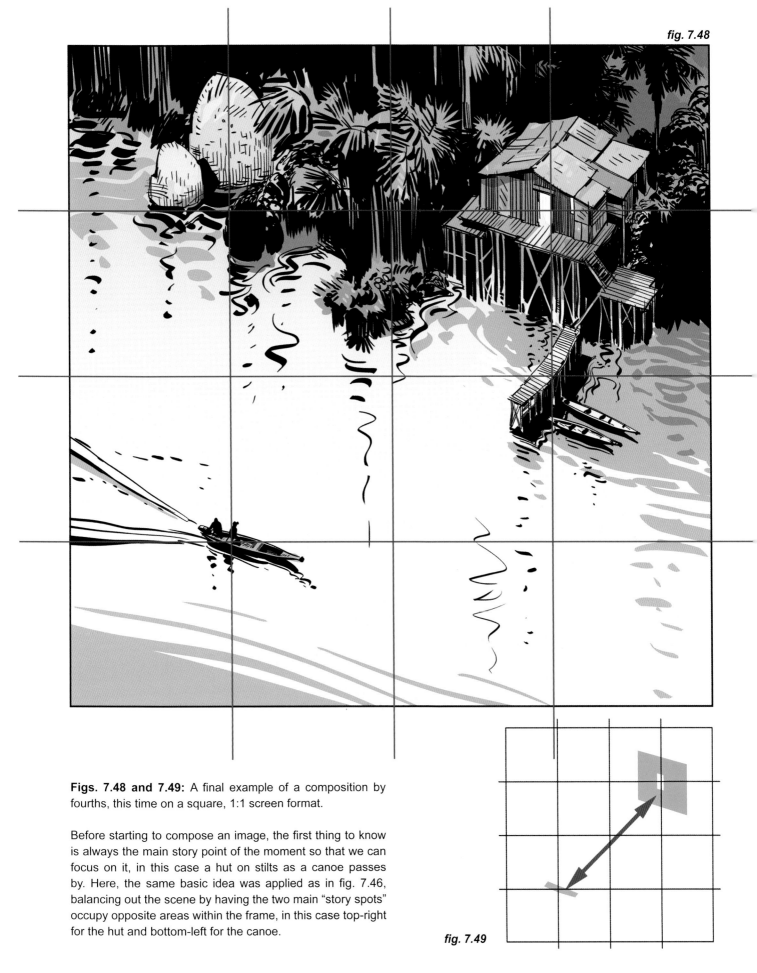

fig. 7.48

Figs. 7.48 and 7.49: A final example of a composition by fourths, this time on a square, 1:1 screen format.

Before starting to compose an image, the first thing to know is always the main story point of the moment so that we can focus on it, in this case a hut on stilts as a canoe passes by. Here, the same basic idea was applied as in fig. 7.46, balancing out the scene by having the two main "story spots" occupy opposite areas within the frame, in this case top-right for the hut and bottom-left for the canoe.

fig. 7.49

DEVELOPING KEY FRAMES FOR A SHORT SEQUENCE

A format always has favorable and unfavorable characteristics as per what we are trying to express visually in any given shot. So *do not focus* on its potential limitations; think about the positive things that a specific format can offer...what that format is good **for** and good **at,** and use *that* to make the shot interesting.

The saying, "if life gives you lemons, make lemonade" is certainly very descriptive of this philosophy, so focus your punch there and squeeze that juice out of it.

The important thing is to be able to (quickly and in a dynamic way) come up with a structure of how to **play and strategize your game** for the scene, and for this we need to be clear about the following:

First, what are the main elements needed to make the story point. For example: an elegant woman arrives at an exclusive marina club to meet someone on a yacht and make a deal...that will eventually lead to an adventure.

So, make a list (written or mental) of the physical elements needed for the scene, in this case:

- the woman
- the marina surroundings
- the yacht
- the yacht's owner

Second, what is the story point of the scene, and how to express it visually.

Is it about how confident she feels about herself, and how she will control the meeting with her personality and charisma?

Is the shot about how much of a tough cookie the owner of the yacht is?

Is it about how rich and powerful the yacht's owner is, symbolized by the elaborate details of the vessel, while we might not even get to see him/her directly?

Is it about the visitor getting herself into a dangerous, shady plot, visually overpowered by a big, dominating vessel that takes up most of the space in the frame?

Or maybe it is a completely relaxed and easygoing scene where the important thing is the surrounding environment?

...just to mention a few possibilities.

Remember, the scene needs to have a meaning and a feeling. The illustration must communicate these to an audience. That is our mission.

The objects themselves are "just" the support, the elements that help materialize this meaning in a visual way.

Once you have figured out all these things, **establish the order of relevance for each element in the scene so that the narrative is clear,** so clear that you barely need words to explain the emotional interactions and relationships between the various characters or elements in the shot.

The **non-physical, non-tangible elements** that give meaning to a scene are:

The **visual importance** of each element in the shot, determined by its **size** or relative **amount of space** it takes up within the frame—how big or small it appears—as well as how much it is enhanced or obscured by **lighting and positioning within the frame.**

The overall **dynamics** (the general flow, push–pull, balance–imbalance, lines of tension, points of inflection, etc.) and how these help to establish a visual sense of drama.

These are the points to explore when drawing preliminary thumbnail sketches.

So, let's get to work on **the different physical elements** for the key shots of this sequence, starting with a 1.85:1 format.

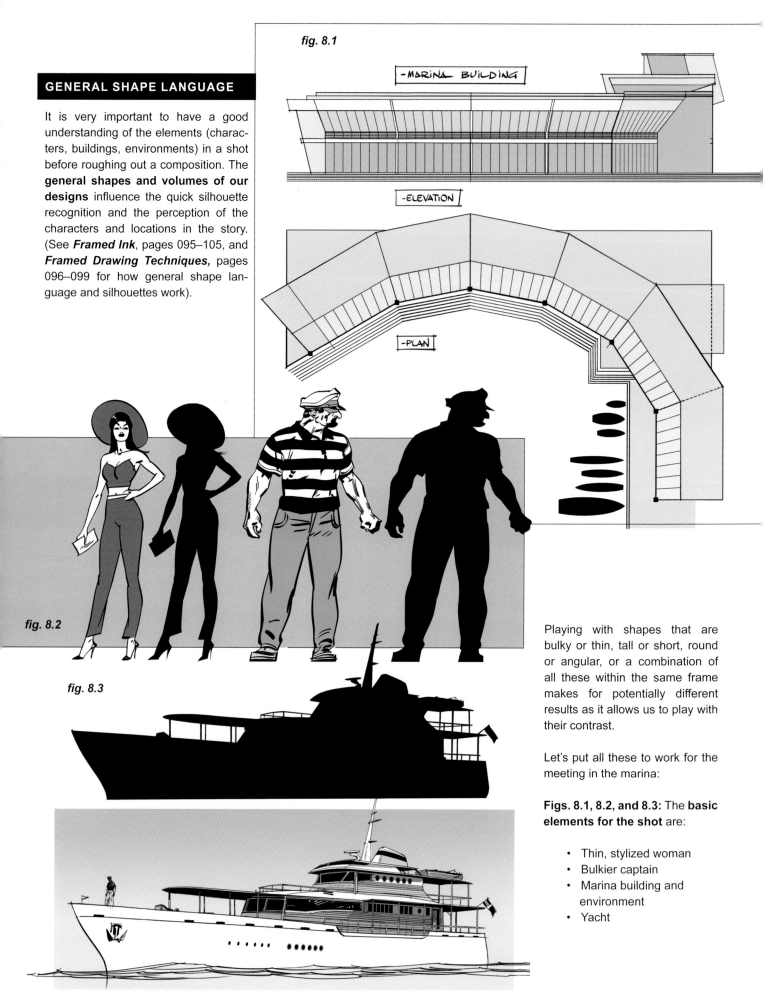

GENERAL SHAPE LANGUAGE

It is very important to have a good understanding of the elements (characters, buildings, environments) in a shot before roughing out a composition. The **general shapes and volumes of our designs** influence the quick silhouette recognition and the perception of the characters and locations in the story. (See *Framed Ink*, pages 095–105, and *Framed Drawing Techniques,* pages 096–099 for how general shape language and silhouettes work).

fig. 8.1

-MARINA BUILDING

-ELEVATION

-PLAN

fig. 8.2

fig. 8.3

Playing with shapes that are bulky or thin, tall or short, round or angular, or a combination of all these within the same frame makes for potentially different results as it allows us to play with their contrast.

Let's put all these to work for the meeting in the marina:

Figs. 8.1, 8.2, and 8.3: The basic elements for the shot are:

• Thin, stylized woman
• Bulkier captain
• Marina building and environment
• Yacht

fig. 8.4

Framed Ink explored how, first and foremost, to **think of the shot as a unit,** as a coordinated effort among all its ingredients, seen from a meaningful point of view (a camera position that focuses on the important story points) and cemented with a purposeful use of lighting and composition.

Quick thumbnail sketches set up the general shape-language of these ingredients, creating meaningful balances, imbalances, and tensions through their contrast and positioning within the frame.

This page has examples of how to think of these components in a simplified way. Is the character bulky? Stylized? Taller, or shorter, than others? Contrast is one of our best allies when composing.

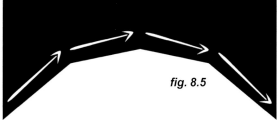

fig. 8.5

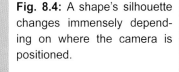

Fig. 8.4: A shape's silhouette changes immensely depending on where the camera is positioned.

The same element (a yacht) can look like a very compressed, square shape if seen from the front, while sideways it becomes a very elongated, stylized visual element.

Figs. 8.1 and 8.5: The marina building looks very different from afoot compared to its aerial view.

These are all compositional elements to consider when beginning to tackle a sequence.

fig. 8.6

fig. 8.7

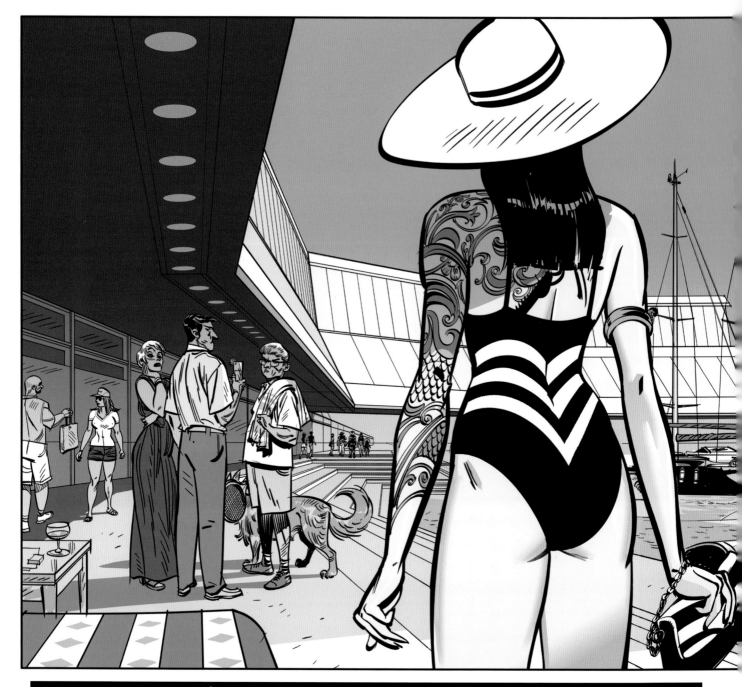

KEY SHOTS – A DAY AT THE MARINA

The **story idea** and the **main elements in it** have been decided. What is the best way to use those elements to tell the story?

With any good story, there are a number of emotional moments, told in continuity, so that together they take us on a **ride that flies from frame A–Z,** and we are eager to know the end. Just like in Chapter 3 when this stream of energy applied to the visual flow of a single composition within a frame, now it must be applied to the overall creation of scenes and sequences to express the full story from beginning to end.

So let's develop our two characters and situation idea into a few frames, **eventually exploring different aspect ratios,** to practice some of the concepts covered so far.

The quick breakdown of the storyline is:

- *Intro to the general setup (an entitled young woman arrives at the marina and confidently walks to a yacht)*
- *She discusses and makes a deal with the thuggish yacht captain (humor can come out of their two clashing personalities)*
- *The two characters embark on a sailing adventure*
- *Eventually she realizes this so-called "seasoned sea captain" is at least as lost at sea as she is (looking at charts in a perplexed way)*

fig. 8.8

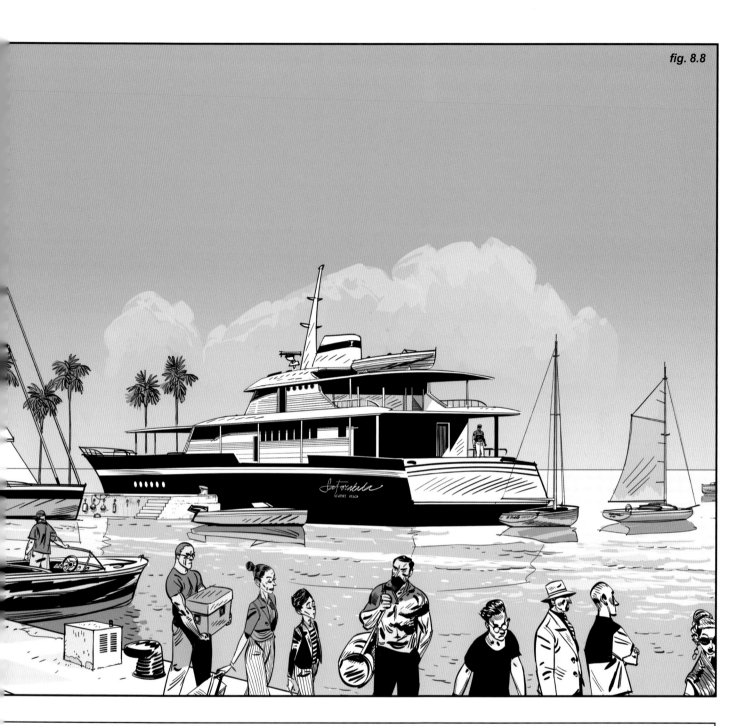

Visual solutions to the same problem can be many. Let's decide that the visual representation of these shots can work as follows:

THE FEELING / EMOTION	ITS PHYSICAL EXPRESSION / SETUP
• Introduction	• Woman makes an entrance to the marina. Spots the yacht, and walks toward it.
• First confusion	• They talk; misunderstandings happen that foreshadow the mess to come
• Excitement	• Shots of open seas, shots of adventure
• Increase in comedic tension	• Things get real when he is obviously lost, looking at charts while pretending to totally know his stuff
• The problem	• Stuck in the middle of a dead calm ocean

Let's start by working all this out in a 1.85:1 frame format, then later tackle these same ideas in different formats to see how to juice it up by using different aspect ratios.

fig. 8.9

fig. 8.12

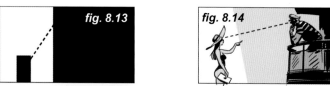

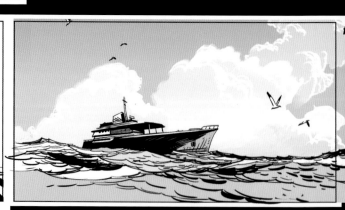

1.85:1 ASPECT RATIO

Fig. 8.9: To introduce the female character the camera is behind her, following her, as she makes an entrance based on abstract concepts like her elegance, sense of fashion and mysterious looks rather than more predictable and straightforward features, such as her face and expression.

The shot is an **implied P.O.V.** (point of view), meaning: we see what she sees yet she is also *in* the shot. This simultaneously allows us to introduce the yacht in the background, the object of her attention as she walks toward it.

Figs. 8.10 and 8.11: These thumbnails show two versions of the basic structure of the shot: a big shape to the left (**1**) and a lower, smaller, counterbalancing shape to the right (**2**), connected by a flowing curve of action and/or a triangle that establishes her and, at the same time, her focus of attention.

Fig. 8.12: The balance between the two shapes, big and small, has switched—with the woman now small on the left and the captain and yacht large on the right—for a more interesting cut. A decision was made to have the characters clearly silhouetted, flat from the side. This simplistic, **somehow naïve** approach of a straight, flat form, can set up a lighter and more amusing tone in the story, as opposed to a more complex and dramatic three-quarter shot, down shot, or upshot.

Fig. 8.14: We could have chosen a more balanced scenario where the heads of both characters are more leveled, but the sillier looking contrast shown by the juxtaposition of both heights in fig. 8.12 makes for a more comedic staging, if so desired.

Figs. 8.15 and 8.16: Adventure time. Close up of the yacht's prow, then cut to a wider shot to give context to the former.

Figs. 8.17 and **8.18:** The ship's point of contact with the ocean (dotted lines) slightly advances from one shot to the next to imply a sense of forward motion.

fig. 8.19

fig. 8.20

fig. 8.21

fig. 8.22

fig. 8.23

fig. 8.24

fig. 8.25

fig. 8.26 *fig. 8.27*

Fig. 8.19: Close up of an "chaotic" marine chart onboard the yacht. It intentionally looks extremely confusing and over-whelming: solid and dotted lines in all directions, triangles, circles, numbers everywhere...and then some.

Fig. 8.20: The thumbnail shows the essential sense of direc-tion of the elements in the shot as established by the circles in it.

Fig. 8.21: To avoid an undesired jump cut between the map and the close two-shot (fig. 8.22, below), it is important to po-sition the 360-degree protractors in the frame (black circles) not to coincide with the faces of the two characters in the next cut (represented by orange blocks).

Fig. 8.22: This is a flat and clear close-up of the two char-acters' reactions to the chart. Clearly, the captain is lost and confused; the woman is very upset with his lack of leadership.

Fig. 8.23: Slight imbalance between the eye levels of both characters.

Fig. 8.24: Straight and simple two-shot composition.

Fig. 8.25: And...they are lost.

Extreme wide shot of their yacht, alone in the middle of nowhere. A dot in the calm immensity of the ocean that con-trasts enormously with the extreme close-up of the previous shot, enhancing their sense of isolation.

Figs. 8.26 and 8.27: It doesn't get any simpler than that as a composition.

By positioning the boat slightly below the center of the frame, it implies the heavier weight of the mass of water above (or-ange section), making for a visually more stressful situation.

Now, let's analyze how these same shots could be **composed for different panel formats.**

Fig. 8.28: The basic key-shot setups were all in the 1.85:1 aspect ratio. Now let's see how to make these same shots work for different screen or panel formats.

fig. 8.28

The three versions on this page show the exact same composition converted to different aspect ratios only by extending both sides of the frames, so the shot's subjects consistently remain in the same size and screen position (orange lines).

1.85:1

2.35:1

Figs. 8.29 and 8.30: Each new frame includes more information at the sides, **although arbitrarily,** not as a result of a thought process that purposely affects the meaning of the shot.

fig. 8.29

4:1

fig. 8.30

A quick analysis of these three frames tells us that:

Fig. 8.31: The **1.85:1** format seems balanced with the frame basically divided into thirds, based on the placement of the woman and the yacht (red dotted lines). However the yacht is pushed off toward the right side of the frame, giving the female character a bit more prominence within the shot.

fig. 8.31

Fig. 8.32: The **2.35:1** frame includes more information to the sides, so we learn more about the environment where the scene takes place, and the image in general breathes a bit more. Also, keeping the characters on the left in shadow prevents them from become too distracting and pulling focus away from the woman.

fig. 8.32

Fig. 8.33: The **4:1** frame has so much going on in the shot, so much information, that by keeping the character and the yacht the same size and position within the frame, their visual importance just got seriously watered down. **She doesn't make much of an entrance anymore,** creating the need for alternative solutions.

fig. 8.33

Fig. 8.34: Obviously, when framed by the 2.35 aspect ratio (fig. 8.29), the woman character is proportionally smaller than when she inhabited a 1.85 frame. To give her the same visual impact she had in the smaller frame, we need to make her actually bigger (fig. 8.34), either through closer proximity to the camera or through the use of a wider lens that exaggerates the perception of the distance between her and all background elements. And for this to have the desired effect, we need to make her—and only her—bigger, while keeping all other elements in the scene their original size.

Fig. 8.35: This is her original size from figs. 8.28 and 8.29 (1.85 and 2.35 formats, previous page). With the help of the red lines, notice how much her size has been enlarged for this new 2.35:1 version.

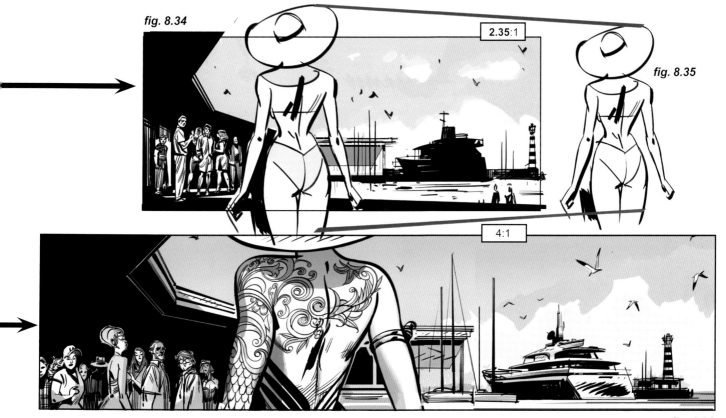

fig. 8.34 2.35:1 fig. 8.35 4:1 fig. 8.36

Fig. 8.36: The first version of a 4:1 composition (fig. 8.30) shows how by enlarging the frame sideways, the extra information does not add anything about the main characters and their moment in the story, thus becoming distracting. So, this **new 4:1 composition has been fully rethought.** To give her entrance the impact it deserves, she was made proportionally even bigger than in fig. 8.34. This meant getting much closer to her, selecting and focusing on elements that would make her more powerful, special and different from the rest of the characters in the shot. A choice was made to be really close to her back tattoos, which she obviously flaunts with pride, while also cropping in further on the background elements, leaving out peripheral areas that were included in fig. 8.30.

Always remember what the point of the scene is. This moment is not about "mystery woman in a marina walks toward a yacht," but about "**mystery woman makes an entrance in front of everyone at the marina,** while walking toward the yacht." So, if she is going to get everyone in the shot's attention, **she will need to get our attention too** and feel (visually) special to us as the audience, either by the amount of real estate she inhabits within the frame, a special use of lighting that makes her pop in the shot, focusing on something that makes her distinctive and special (the tattoos), or all of the above. Next, let's move on to **SHOT #2.**

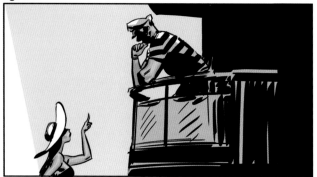

fig. 8.37

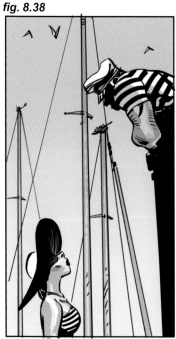

fig. 8.38

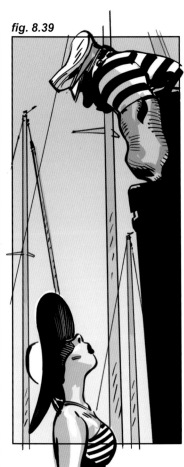

fig. 8.39

Fig. 8.37: We start with the 1.85 version of this dialogue scene.

Fig. 8.38: A vertical 1.85 frame includes the masts of some sailboats in the background that enhance the verticality of the shot, adding a sense of surrealism to the scene and becoming a visual element of separation between the two characters, indicating a level of conflict or tension (see *Framed Ink*, page 036).

Fig. 8.39: A 2.35 frame stretches the image vertically even further, which **brings her really close to the ship's hull** and forces her to look almost straight up at the captain. This, together with the dead-on flat, silhouetted composition, makes for a cartoony situation.

Fig. 8.40: The 4:1 format can play the scene as a regular two-shot or...

Fig. 8.41: By cheating the height of the yacht's deck and bringing the camera really close to the characters, it can focus on the acting and the heavy sarcasm in both dialogue and character expressions. The shots could play individually or one after the other, a progression in the scene's action as we close in on the characters.

fig. 8.40

fig. 8.41

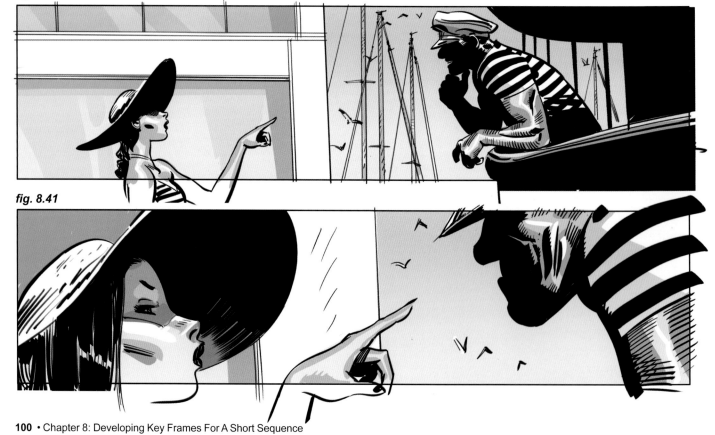

fig. 8.42 fig. 8.43 fig. 8.44

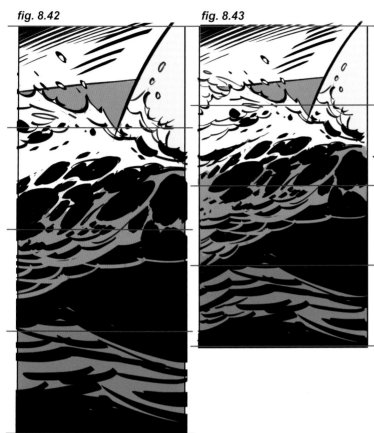

Figs. 8.42 and 8.43: For **SHOT #3,** the action is quite simple, just two elements—the base of the hull and the ocean—as our characters sail away. The 2.35 and 1.85 vertical formats offer a choice between showing more of the hull and less of the ocean, or vice versa. The latter wins out as the ocean offers more visual interest with its changes in shapes and dynamics, compared to the flat, fiberglass surface of a hull. (In both cases the composition is divided by fourths—see red lines).

Fig. 8.44: For **SHOT #4,** a horizontal 1.85 frame works well for a nice, balanced wide shot of the yacht and the surrounding ocean.

Figs. 8.45 and 8.46: The more extreme width of the 4:1 format again offers two choices: show more of the sky or more of the ocean. The sky can symbolize a grand sense of open space and freedom. A heavier look at the ocean could bring a more ominous take by focusing on the deep blue and all the unknown that lies beneath as the adventure progresses; it really is about what kind of tone we need for the shot.

fig. 8.45

fig. 8.46

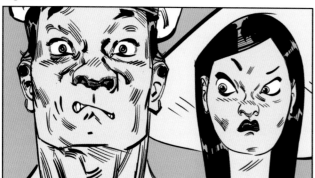

fig. 8.47

fig. 8.48

fig. 8.49

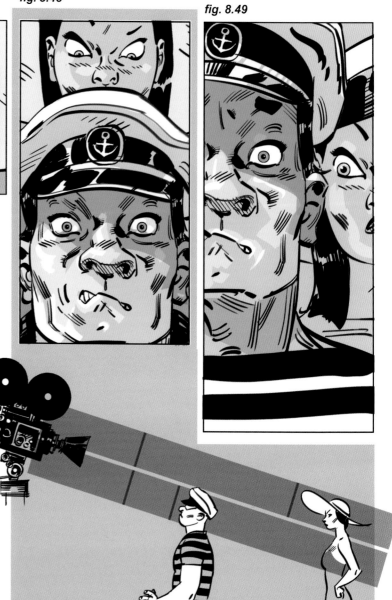

Fig. 8.47: As it is more about the contrast with the next shot that we already discussed on page 97, we'll skip analyzing **SHOT #5** of the map and jump to **SHOT #6,** the close two-shot of them looking at the sailing chart, focusing on his total confusion (action) and her frustration (reaction) at the mess he got them into.

Figs. 8.48 and 8.49: The vertical format focuses solely on their expressions, eliminating everything else from the picture and going straight for their acting.

Fig. 8.50: This is the camera position for fig. 8.48, which has a 1.85 format. The camera is positioned where the charts are in the scene. The use of a really long lens visually flattens out the image and compresses the two characters in the shot, eliminating the perception of depth and distance between the two.

Fig. 8.51: The 4:1 shot below approaches the scene with the same "in their faces" philosophy, only this time there is a lot of extra space on both sides of the characters. As always, every part of the screen should be used to enhance the meaning and purpose of the shot, so here, this extra space reinforces the tone of the moment by doubling down on the idea of total chaos, as seen in the completely disorganized command center of this so-called "Captain's" yacht.

fig. 8.50

fig. 8.51

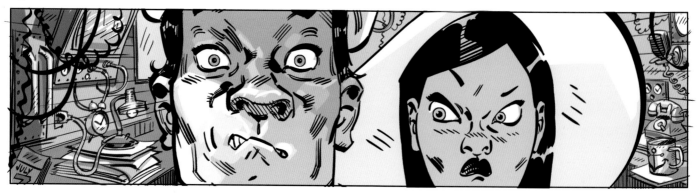

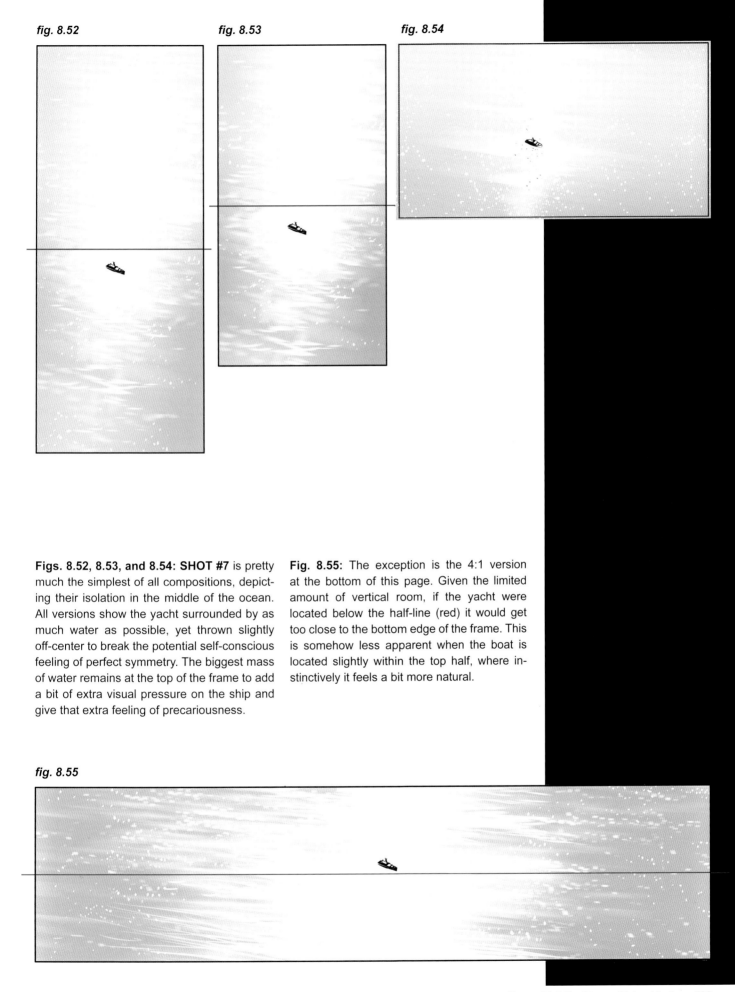

fig. 8.52

fig. 8.53

fig. 8.54

Figs. 8.52, 8.53, and 8.54: SHOT #7 is pretty much the simplest of all compositions, depicting their isolation in the middle of the ocean. All versions show the yacht surrounded by as much water as possible, yet thrown slightly off-center to break the potential self-conscious feeling of perfect symmetry. The biggest mass of water remains at the top of the frame to add a bit of extra visual pressure on the ship and give that extra feeling of precariousness.

Fig. 8.55: The exception is the 4:1 version at the bottom of this page. Given the limited amount of vertical room, if the yacht were located below the half-line (red) it would get too close to the bottom edge of the frame. This is somehow less apparent when the boat is located slightly within the top half, where instinctively it feels a bit more natural.

fig. 8.55

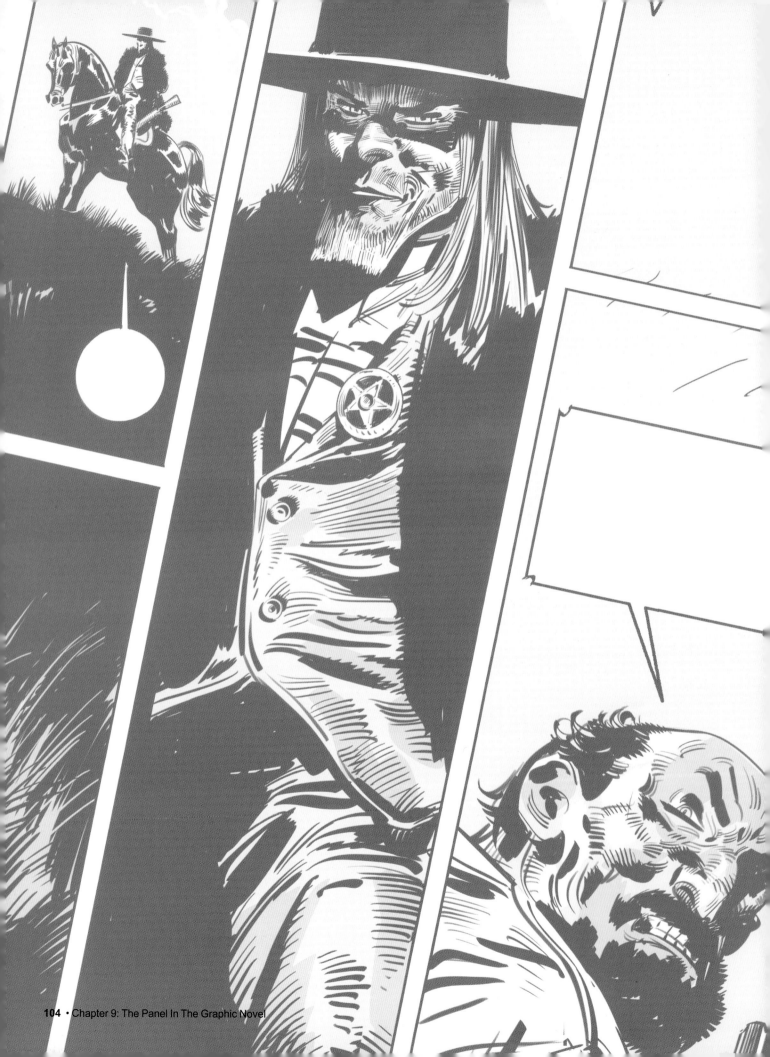

THE PANEL IN THE GRAPHIC NOVEL

The way the panel works in a graphic novel is a very different ballgame compared to a movie or mobile device's screen, for a number of reasons. First of all, a graphic novel can make use of all frame formats within the same story, within the same page, and even physically break the boundaries of each panel to put some elements partly outside of the frame.

Furthermore, using different aspect ratios at the same time creates the opportunity to play one against the other, that is, contrast the panels as part of the visual game. We can use narrow frames to enhance claustrophobia, open frames to emphasize space, regular-shaped rectangles or squares for moments of calm or relative calm, and crazy irregular shapes for moments of action or stress. We can split pages into numerous panels, or let one single frame expand across two full pages with the spectacularity this brings to the visual story.

So far, we have been talking about composing individual frames; but in a graphic novel every two-page spread becomes a visual narrative unit in its own right within the context of the full story, and it needs to be composed as such, keeping in mind that this is how the audience will experience it.

The possibilities are literally endless, and the levels of complexity will vary from the simplest to the most intricate we can imagine, always depending on the needs of the story.

fig. 9.1

Fig. 9.1: These panels are part of an opening sequence from *Trail of Steel 1441 A.D.* that briefly tells a snippet of something that happened long before the actual adventure started, giving us important clues about the personality and relationship between the two main characters.

fig. 9.2

 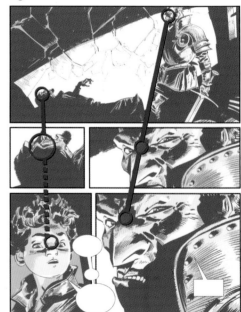

At this point, things are subtle and understated; it's a slow beginning full of shadows in both the story and the artwork. Although there is some variety in the panel formats and sizes, there are definitely no big changes in them. It is all designed with a restraint that visually reflects the eerie and quiet atmosphere of the moment.

Neither is there a dynamic cutting back and forth to different moments and locations. In fact, four of the five panels are different ways to crop the same exact moment or scene: **Frames 2** and **3** are tighter shots of the characters from **frame 1,** and **frame 5** is barely a slight push in on **frame 3** (in a taller frame to get the warrior's full facial expression). Only **frame 4** cuts away to a reaction shot of the mercenary's son.

Fig. 9.2: In order to keep the quiet, smooth flow of the page as a whole, the characters (mercenary #1 standing, mercenary #2 on the ground, and the young boy) are always positioned along the exact same lines throughout the page.

Fig. 9.3: This is a case of total restraint on the part of the camera, which is locked in the same position for the duration of the scene, merely witnessing the character revolve around on the set while having a phone conversation.

fig. 9.3

Fig. 9.4: Continuing the saga of the mercenaries...at some point the old mercenary and his son are inside a temple that turns more and more into a complicated maze. The only available path out is a narrow staircase that leads all the way up to a door, a path they become aware of only because numerous rats slowly creep in that direction. They decide to walk up the narrowing staircase.

The previous pages in the story had more regular-shaped panels. Now we take a visual turn, laying out these panels to become more and more vertical and narrow, emphasizing the characters' sense of claustrophobia inside this labyrinthine location.

fig. 9.4

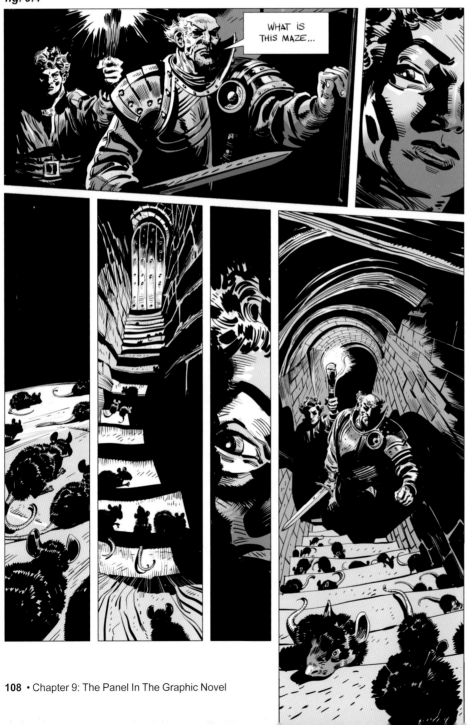

Fig. 9.5: And here is the total opposite. After the suffocating and dark scene in the maze, and its eventual resolution, we suddenly cut out to the open view of a formidable mountain range, laid out as a full double-page spread. In order to cut to the action of the caravan of soldiers traveling through these mountains, we do so by including their cut-in panel right inside the bigger double-spread panel.

These examples show how **adjusting a frame's aspect ratio and its size/proportion within the page** can reflect and emphasize the feeling we would have if we were physically in the featured location (claustrophobia vs. openness, in this case). We have always talked about how important it is not just to provide or spoon-feed information to the audience so they can rationally understand the story, but to visually take them inside of it so that it becomes their own experience.

fig. 9.5

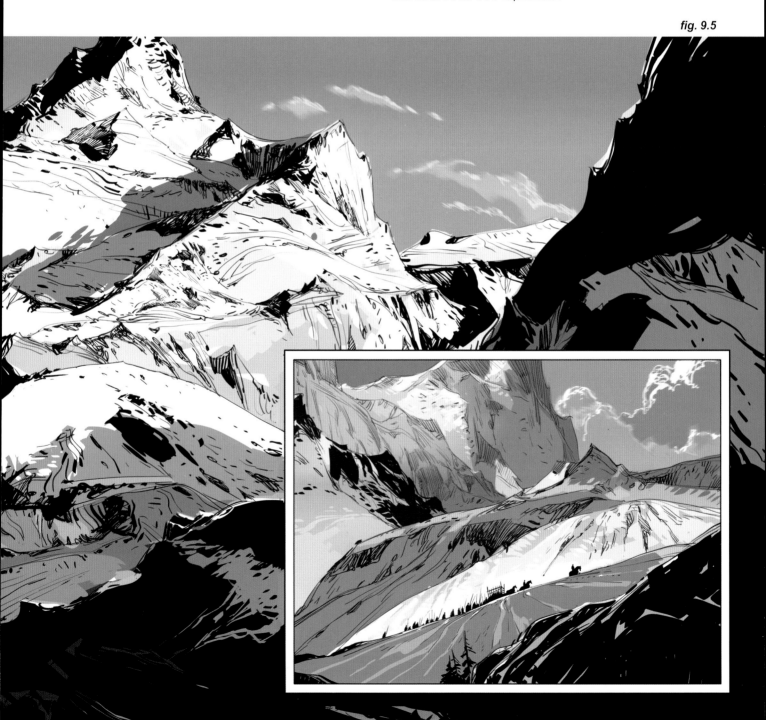

Figs. 9.6 and 9.7: In this set of two consecutive pages, three soldiers are getting ready to fight for their lives while protecting some prisoners they have been put in charge of. The moment is very tense and eventually leads to full combat when on the second frame of the second page the enemy unexpectedly breaks into their fortress and the battle begins.

The panels echo the stress of the moment by going in all different angles and directions; one of the dividing lines even zig-zags.

Again, to make the layout of this fighting scene come across as powerful, not only was it designed in a dynamic way, but the scenes and pages before and after it were designed with a much more subdued layout, just basic vertical and horizontal partitions as much as possible with all frames having a similar surface area, keeping the contrast among themselves to a minimum. Then, suddenly, the serene mood breaks with a more powerful layout as fighting begins.

Fig. 9.8: Here we revisit the extreme vertical format of fig. 9.4, but with another narrative effect. Fig. 9.4 was about a feeling of claustrophobia, fig. 9.8 is about power. Picture this: Sheriff Montana, after years of hunting through the southwest for outlaw Johnny Robber, has finally caught him by surprise. Now Montana is in control of the situation, on top of a hill, looking down on the criminal.

We establish this control and power through the height difference in the positioning of both characters' eye levels within the page's layout. Montana's eyes are at the exact same height in all his panels—same for Johnny Robber—only Johnny's eyes are in a much lower position. The narrow format of the panels also allows us to shave off all unnecessary information surrounding the characters, to focus solely on their intense expressions, enhancing the visual drama and tension of the scene.

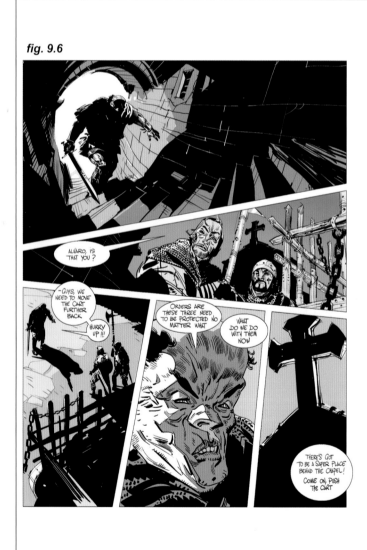

fig. 9.6

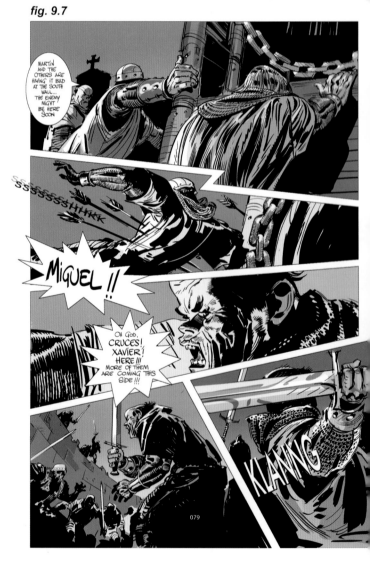

fig. 9.7

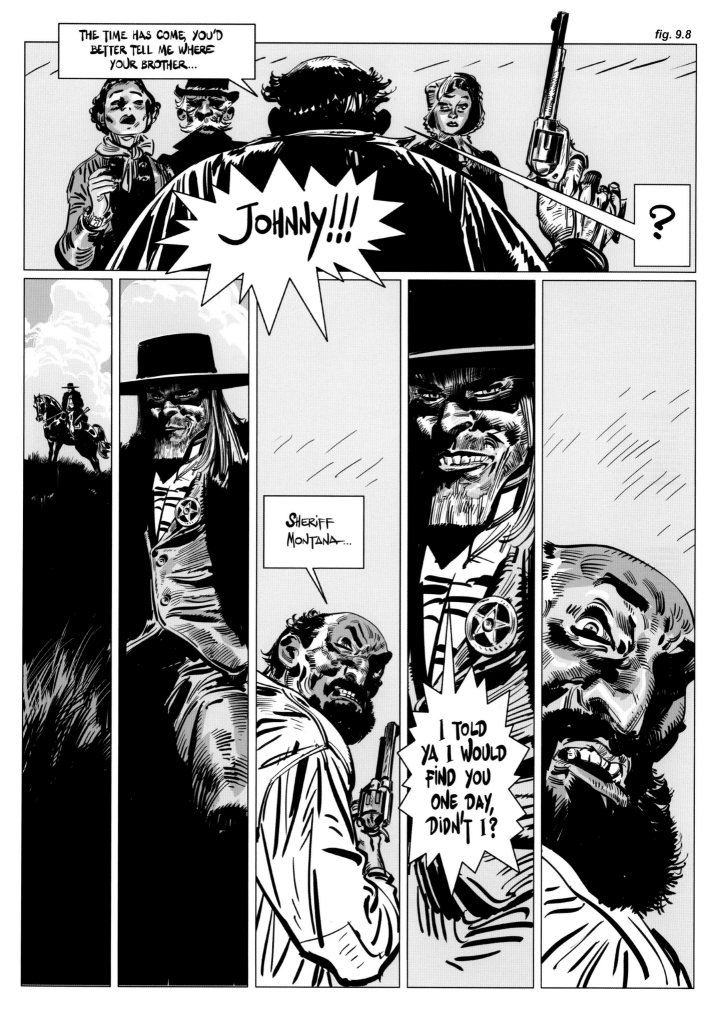

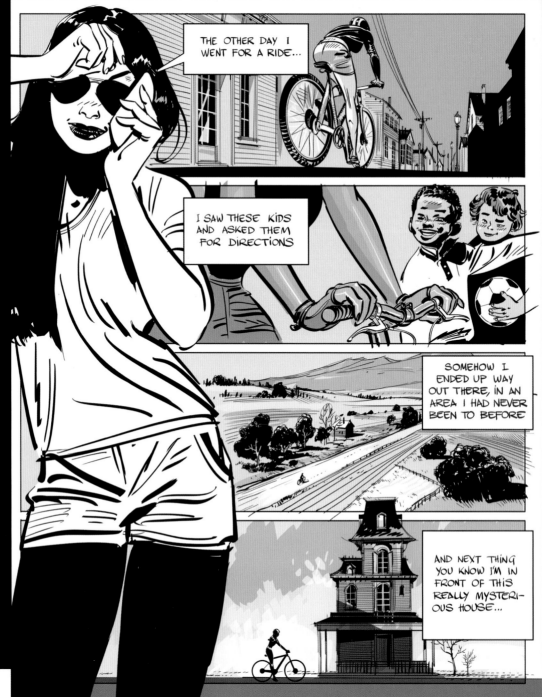

Fig. 9.9: Here we have a woman on the phone with a friend, relating, step by step, her recent experience during a bicycle trip.

Having her story visually explained in the background with a succession of equal format, horizontal panels, while she is pictured vertically throughout the full page, from top to bottom, turns her into the one element in the layout that connects all of these story points, making her the central and common element in the event she is narrating.

As mentioned before, the examples in this chapter are just a tiny indication of the visual possibilities a graphic novel can offer. **The compositional guidelines detailed in the previous chapters of this book apply to the creation process of each individual panel in a comic** and yet, in addition to this, a graphic novel presents us with the task **to simultaneously create through the succession of these panels, within a page first, then the double-page spread, and finally the full story, a fascinating and complex experience in visual storytelling.**

10

PROCESS AND GALLERY ANALYSIS

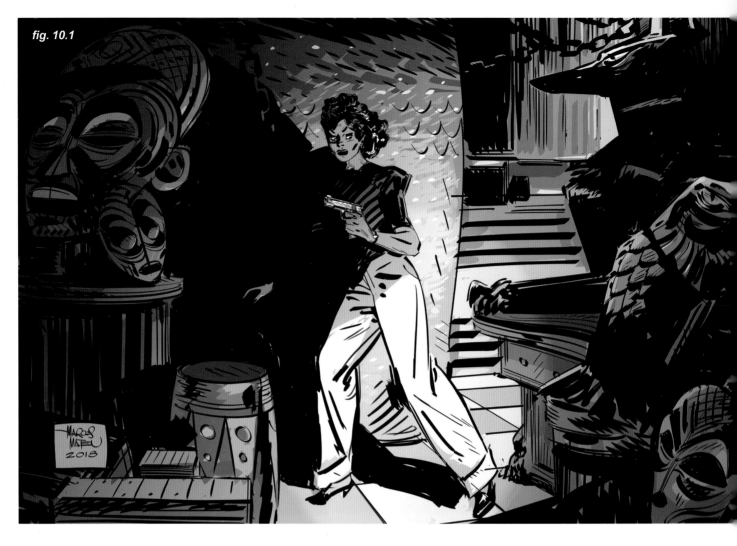

fig. 10.1

fig. 10.2

Fig. 10.1: Backstage mystery.

Fig. 10.2: Cropped and rearranged composition basically with the same elements as fig. 10.1 to obtain a vertical frame of the same moment. In this version the bad guy is not hiding ahead of her but is actually positioned behind her, at the top of the steps.

Fig. 10.3: Section 1 of this composition, which frames the deepest and farthest plane from the camera, is the narrowest. Sections indicated as 2 and 3 get wider as they show planes that are closer to the camera as a way to enhance the overall sense of perspective.

Fig. 10.4: Very distinguishable graphic shapes are created by the placement of these Egyptian-style sculptures, silhouetted in dark over a light background, as seen in this particular detail.

fig. 10.3

fig. 10.4

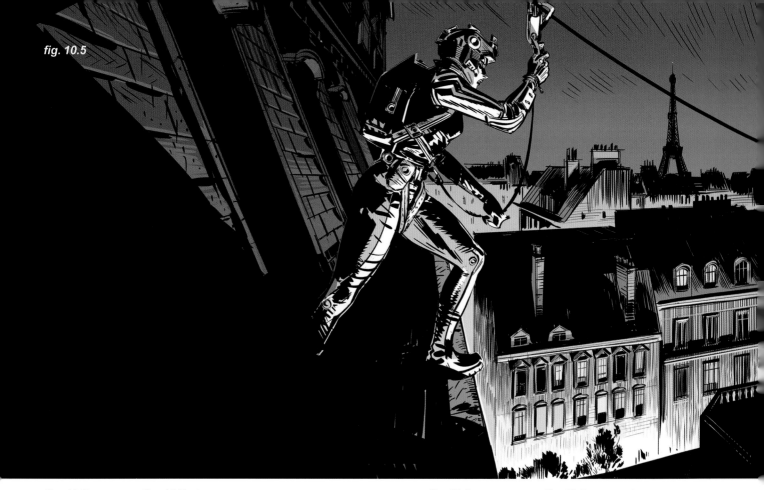

fig. 10.5

fig. 10.6 fig. 10.7

fig. 10.8 fig. 10.9

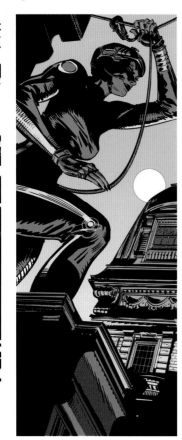

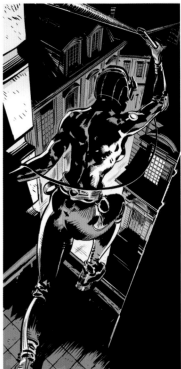

Fig. 10.5: Wide shot of the rooftops of Paris as a backdrop for a heist scene.

Figs. 10.6–10.9: Preliminary sketches and final renders of two vertical-format versions.

Fig. 10.6: While looking for a graphic silhouette, the character in the preliminary sketch was in a straight side-view perspective (in blue), but the 3/4 upshot was required for the best perspective of the buildings (in red).

Figs. 10.10 and 10.11: Two exploratory sketches based on the same story moment idea.

Fig. 10.12: A 1:1, square-format version

fig. 10.10

fig. 10.11

fig. 1.68

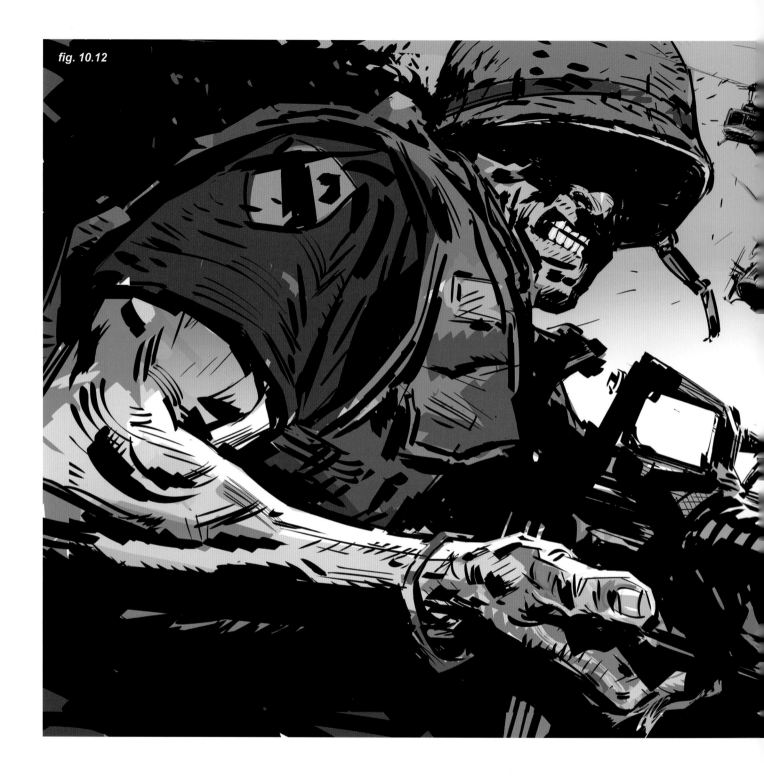

fig. 10.12

Fig. 10.13: A strong sense of depth between the foreground characters, the fighting, and the distant helicopters in the background helps drive the overall sense of action and dynamics of this shot.

These helicopters as a group are designed to follow a sense of "animation," meaning there are five of them yet compositionally they work as different poses of the same helicopter getting closer to the camera, as explained in *Framed Ink* (page 039).

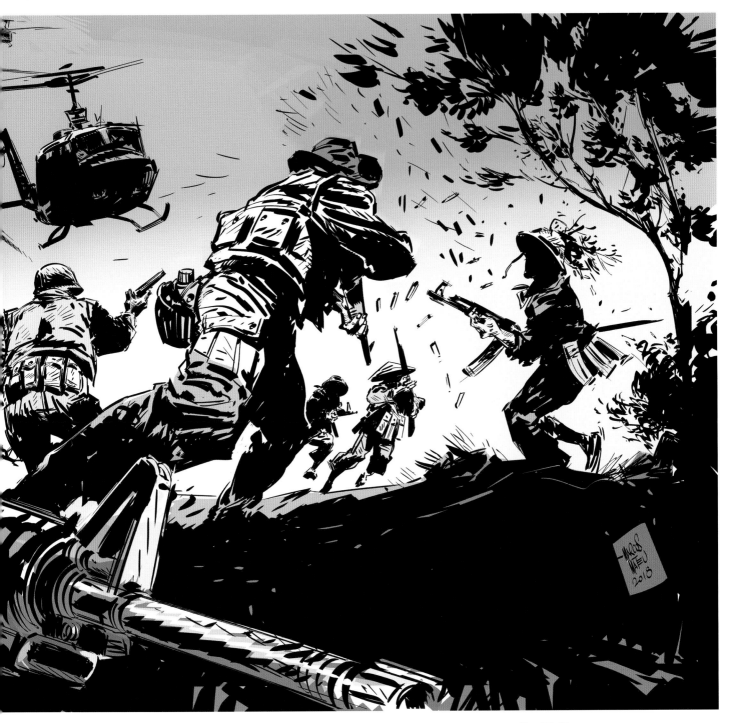

fig. 10.13

fig. 10.14

Fig. 10.14: Helicopters "animation" sketch.

Fig. 10.15: Helicopters final render detail.

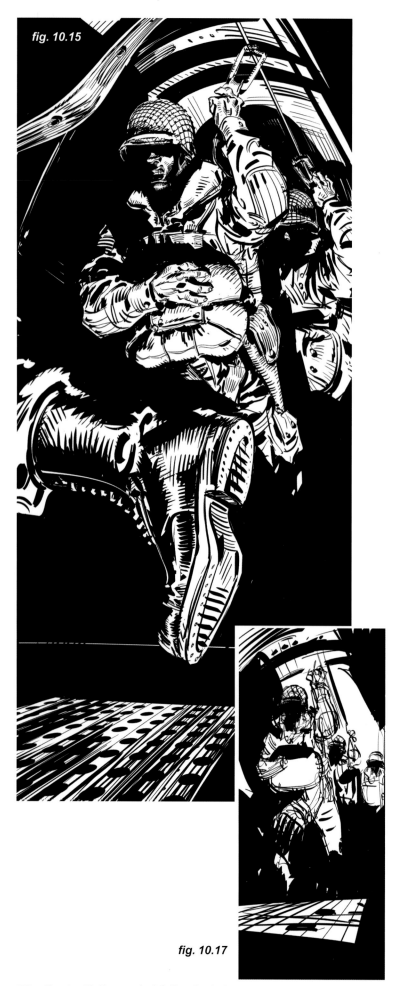

fig. 10.15

fig. 10.16

fig. 10.17

fig. 10.19

fig. 10.20

fig. 10.18

fig. 10.21

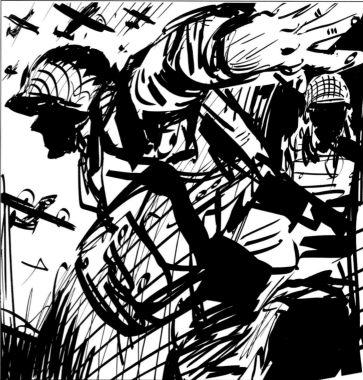

Figs. 10.16, 10.17, and 10.18: Vertical aspect ratios for these parachuters about to jump.

(Note: While working on it I was listening to a soundtrack of WWII bombers' engines. These things are great when it comes to getting into it!!)

Fig. 10.18: Showing a sense of claustrophobia (refer to page 108).

Fig. 10.19: A quick, preliminary silhouette/dynamics sketch. Sharpie on copy paper.

Figs. 10.20, 10.21, and 10.22: Paras action, square format. Rotating the camera around the action to obtain different effects.

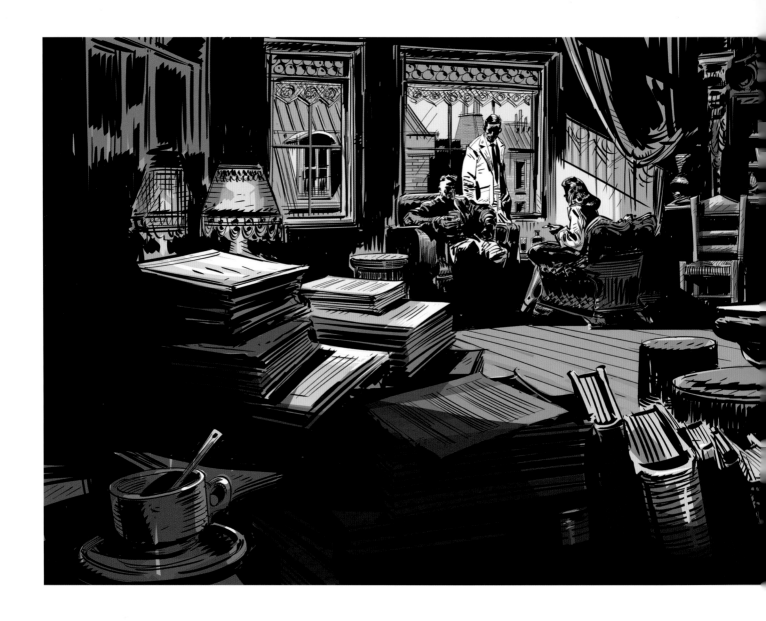

fig. 10.22

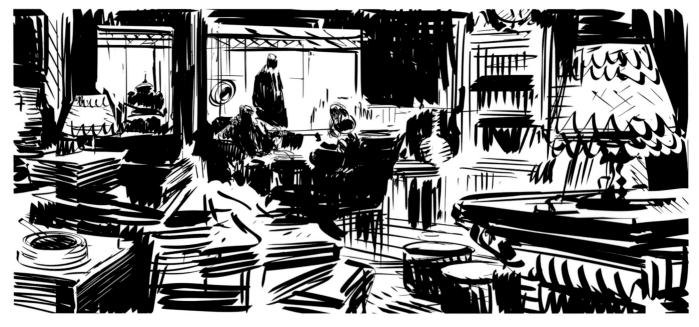

fig. 10.23

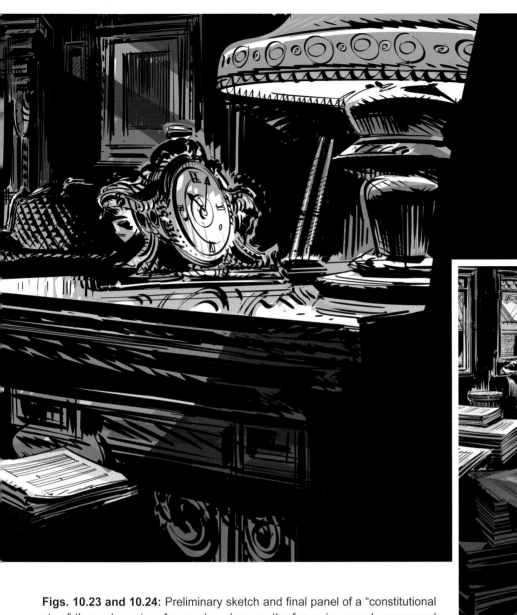

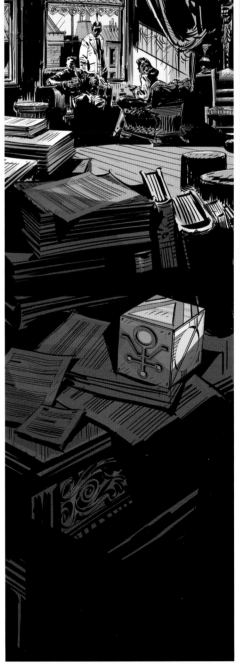

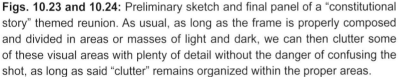

Figs. 10.23 and 10.24: Preliminary sketch and final panel of a "constitutional story" themed reunion. As usual, as long as the frame is properly composed and divided in areas or masses of light and dark, we can then clutter some of these visual areas with plenty of detail without the danger of confusing the shot, as long as said "clutter" remains organized within the proper areas.

In this case, the elements that help establish the personality of the character this house belongs to (the desk, books, paperwork, furniture style, etc.) are spread over an area that visually frames the conversation of the characters without interfering with it.

Fig. 10.25: A vertical composition like this one offers the special opportunity to include a new and parallel center of attention beyond the three main characters, such as this mysterious box in the foreground that we can obviously assume will be somehow directly related to the story the characters are discussing at this very moment.

fig. 10.24

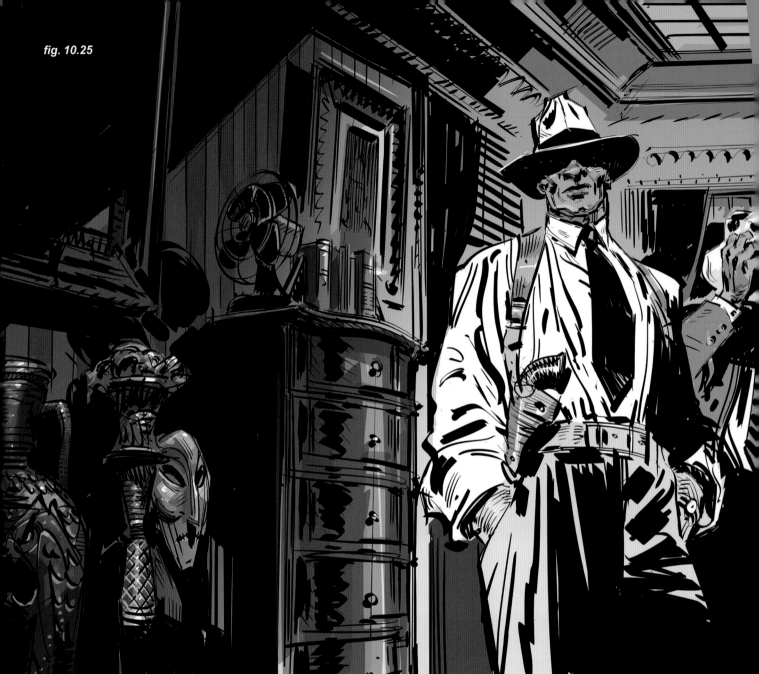

fig. 10.25

fig. 10.26

And finally, wrapping it up now with four additional panels:

Two different points of view or camera placements on the "Protecting The Witness" shot.

Fig. 10.26: The female witness is close to camera and the policemen are a few feet further down.

Fig. 10.27: The camera is now behind the cops, leading our eye all the way up to the seated witness in the distance.

Fig. 10.28: "City Rooftops Chase"

Fig. 10.29: "Venice Intrigue"

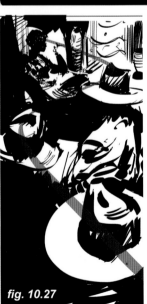

fig. 10.27

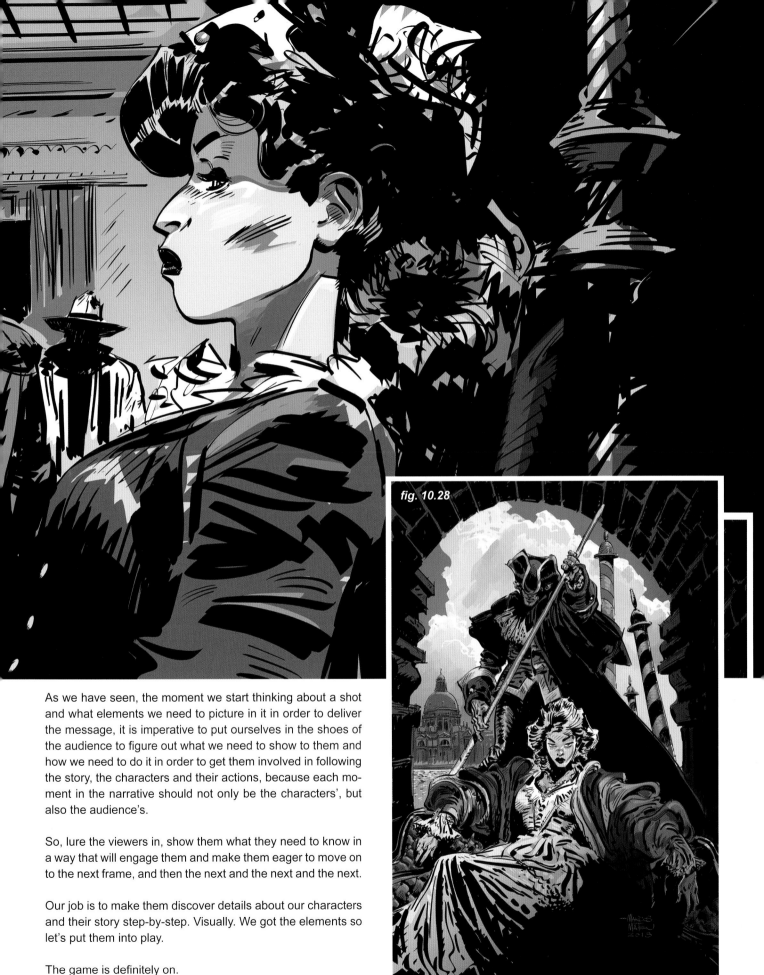

fig. 10.28

As we have seen, the moment we start thinking about a shot and what elements we need to picture in it in order to deliver the message, it is imperative to put ourselves in the shoes of the audience to figure out what we need to show to them and how we need to do it in order to get them involved in following the story, the characters and their actions, because each moment in the narrative should not only be the characters', but also the audience's.

So, lure the viewers in, show them what they need to know in a way that will engage them and make them eager to move on to the next frame, and then the next and the next and the next.

Our job is to make them discover details about our characters and their story step-by-step. Visually. We got the elements so let's put them into play.

The game is definitely on.

Index